Under the sun

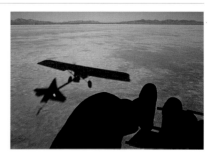

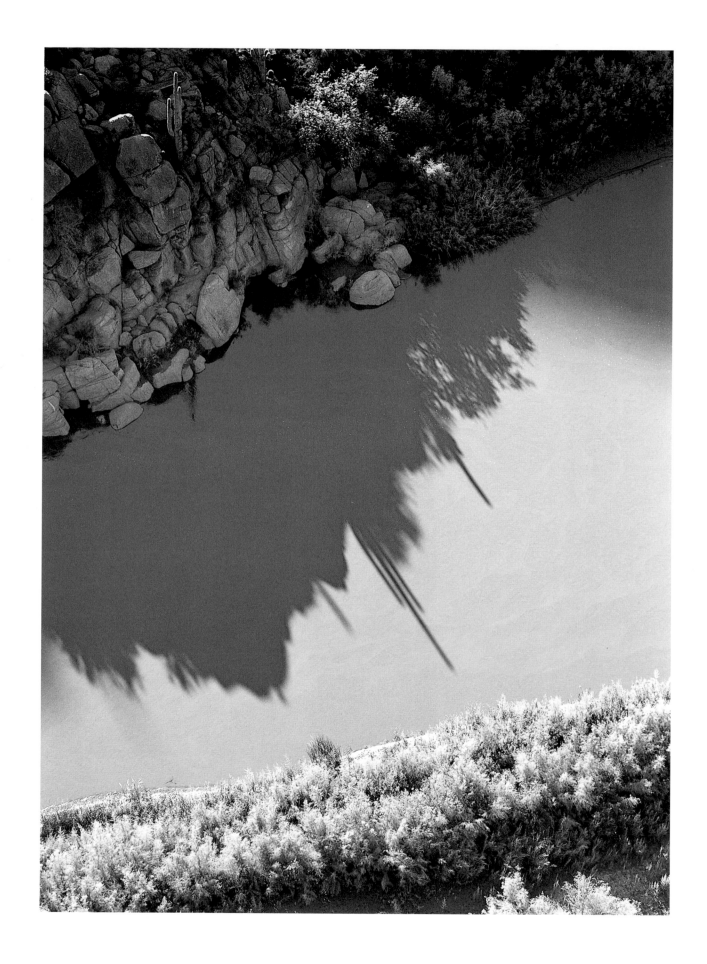

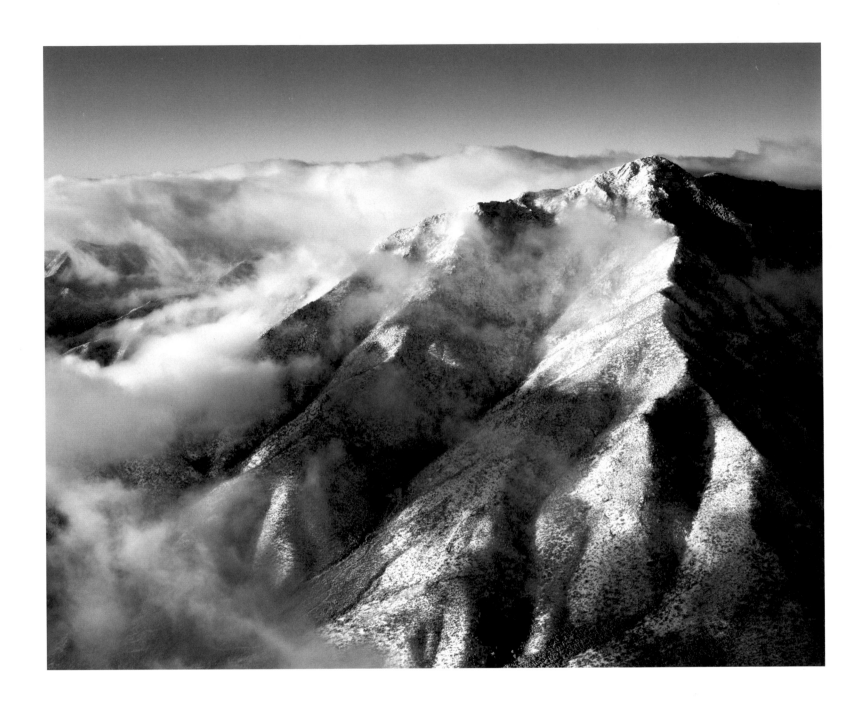

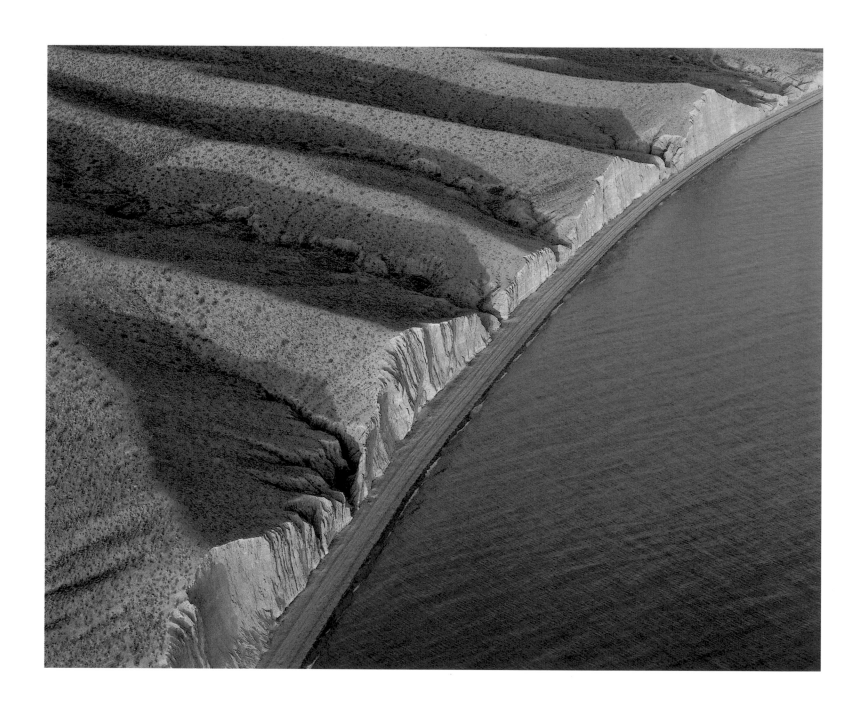

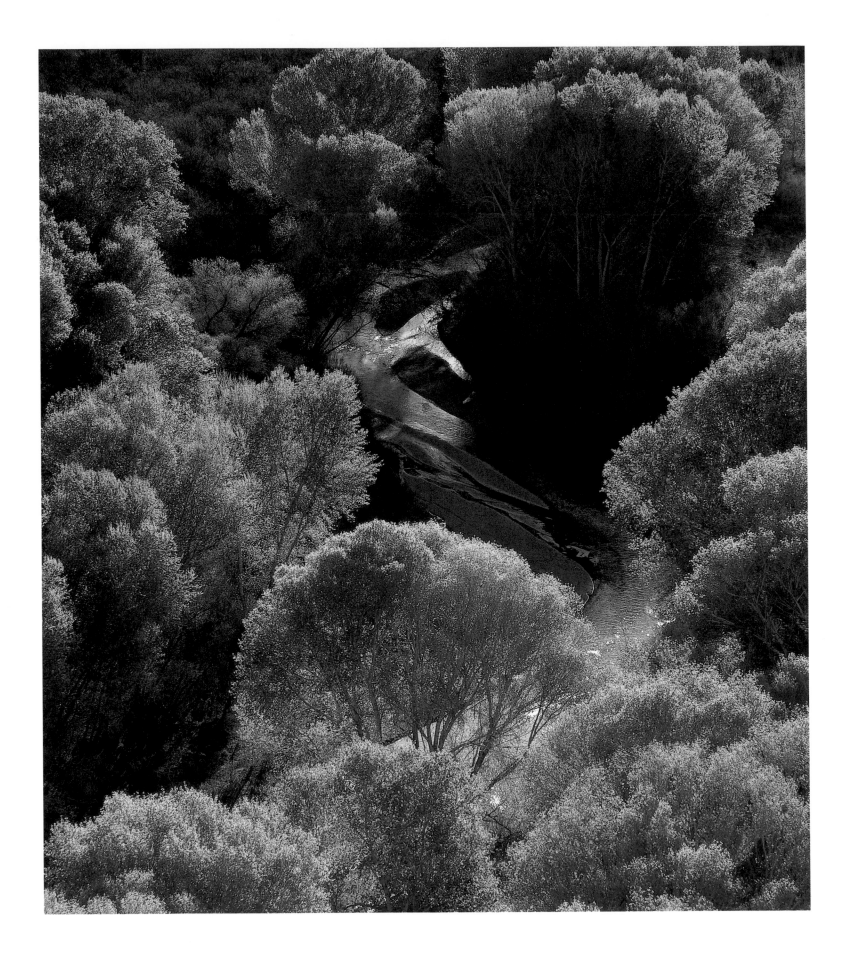

UNDER THE SUN

A SONORAN DESERT ODYSSEY

ADRIEL HEISEY

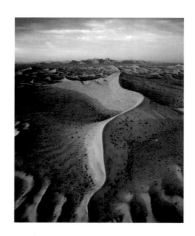

For Jack Zeigler,
 who believed in me.

Rio Nuevo Publishers

an imprint of Treasure Chest Books

P.O. Box 5250

Tucson, AZ 85703-0250

(520) 623-9558

ISBN 0-9700750-0-6

10 9 8 7 6 5 4 3 2 1

Editor: Susan Lowell

Editorial Assistance: Ronald J. Foreman

Designer: David Skolkin

Printed in Korea

iii: *Salt River Canyon Wilderness, Arizona*

iv: *Miller Peak Wilderness, Hauchuca Mountains, Arizona*

v: *Coastline south of Cabo Tepoca, Sonora*

vi: *San Pedro River near St. David, Arizona*

112: *Photo courtesy of Joel Brown*

CONTENTS

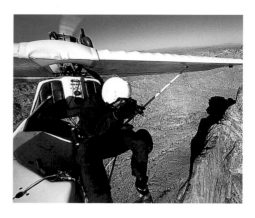

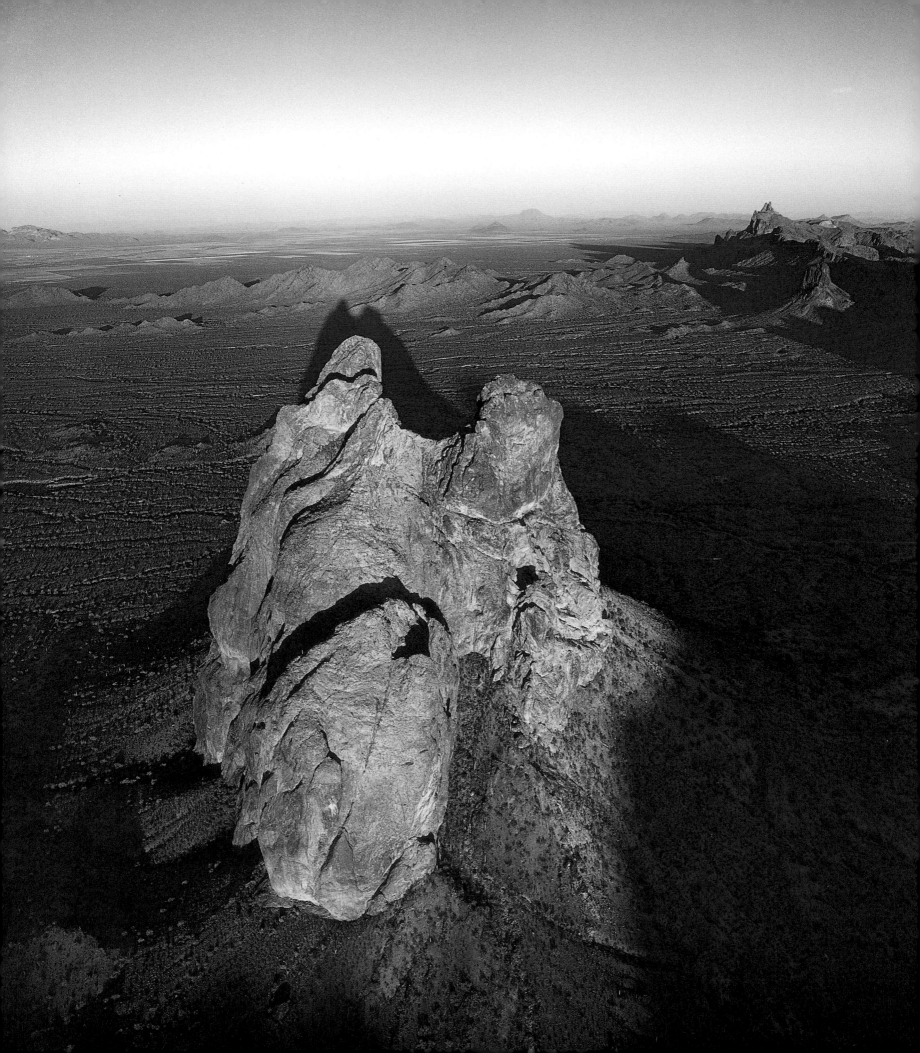

INTRODUCTION

AM NOT A NATIVE OF THE SONORAN DESERT. I can't even claim that I'm here because the land spoke to my soul, or because I sought new lifeblood for my art. The fact is, I moved here for the love of a woman, and everything else in my life found its place around that.

In *Fire in the Belly: On Being A Man*, Sam Keen writes that there are two questions a man must ask himself: "Where am I going?" and "Who will go with me?" Keen warns that if a man gets these in the wrong order, he is in trouble.

The stories and images for this book began shortly after I answered the second question. Despite the way it sounds, I'm not in trouble. My answer to the first question has never been a

problem: it's always been some variation of "UP." Getting to the next question, however, took me thirty-eight years. When I finally settled it, I was delighted to find it was also the perfect occasion for a midlife course change.

I turned from a stable career of flying multimillion-dollar corporate airplanes to an uncertain life of flying my homebuilt ultralight—from salaried security to fickle freelancing.

Without actually planning this change, I'd been preparing for it for years. I had learned about shooting photographs from airplanes by carrying my camera with me in the cockpit—something I'd done since I took my earliest flying lessons as a teenager. At age twenty-seven, I became a pilot for the Navajo

Nation, where my daily flights over the Four Corners region filled me with more beauty than I could hold. My photographs were my only true relief—and evidence—for this extraordinary burden. When I eventually decided I wanted to take even more and better pictures, I built a plane for the task. It was simple, slow, open, inexpensive—and my own. At last, I could fly purely for aesthetic purposes. I stayed hard at work on the tribal flight line, but the sky opened up to me in a new way, and in four short years I had thoroughly proven my system.

By that time, I clearly knew my answer to the second question. It was Holly. She had two children, a midwifery practice, and a house in Tucson, Arizona, and since I was ready to revise my answer to the first question, I quit my job, married, and moved to Tucson to start a new life.

After a decade of flying and photographing in one of the planet's most colorful and dramatic landscapes, I must admit the Sonoran Desert didn't inspire me when I first came to live here. The landforms were austere and repetitive. They looked tired and worn down, their heyday long passed. Whether bare cliff, jumbled bajada, or alluvial plain, the palette of colors was drab and unimaginative. I couldn't shake the feeling that all the land was scorched. The plants seemed unfriendly, ungainly, straggly, and miserly. They looked as if they were barely making it themselves, let alone able to offer succor to any other life. I didn't feel welcome.

And then there were the cities. I had held Arizona's urban growth in quiet contempt when I lived in Window Rock, diminutive capital of the Navajo Nation. I would sally forth by air to Phoenix or Tucson on tribal business a couple of times each week, always thankful I'd soon return to the fresh clear air and empty spaces of the north country. I had wondered what the millions of recent arrivals to Maricopa and Pima counties could know of the *real* Arizona as they huddled in their cloisters like colonists on the moon. Now, I was one of them.

I had some reconciling to do. Flying was the key, because in my slow, open plane I feel as though I am part of everything around me. Earlier in my life, up on the vast Colorado Plateau, this sense of affinity centered on the land itself, and on the gentle footprint of Indian lifeways. Now, living near a desert metropolis, I began to face the more problematic side of my connectedness. If I saw development of the desert as a cancer, was I one of the diseased cells? If I wasn't, then who was? What if my aging parents want to move here to be close to me? Where will my stepchildren live when they grow up? *Their* children? If I answered truthfully, I knew I could be implicated in what I disdained.

My prejudices against the landscape began to soften. I explored and discovered the land for myself in my plane, letting it confront me with my own ignorance. I found things I could not have known or expected beforehand, and they lodged in me unforgettably. I wanted to learn more about what I was seeing, and that in turn allowed me to see more. The perpetual motion of this cycle has moved me to a new appreciation for the desert. I now see a rich and varied geological story where I once saw monotony. I see amazing feats of adaptation where I once saw hostility. I see nuance where I once saw bleakness. I see fragility where I once saw harshness. No longer an outsider, I have grown to love the Sonoran Desert. This book is the story of my journey.

Very few of us who live in the desert are natives. Our reasons for coming here are myriad. But now that this is our home, our collective welfare depends on understanding it. As we take from the desert what we need to thrive, it is incumbent upon us to offer awareness in return.

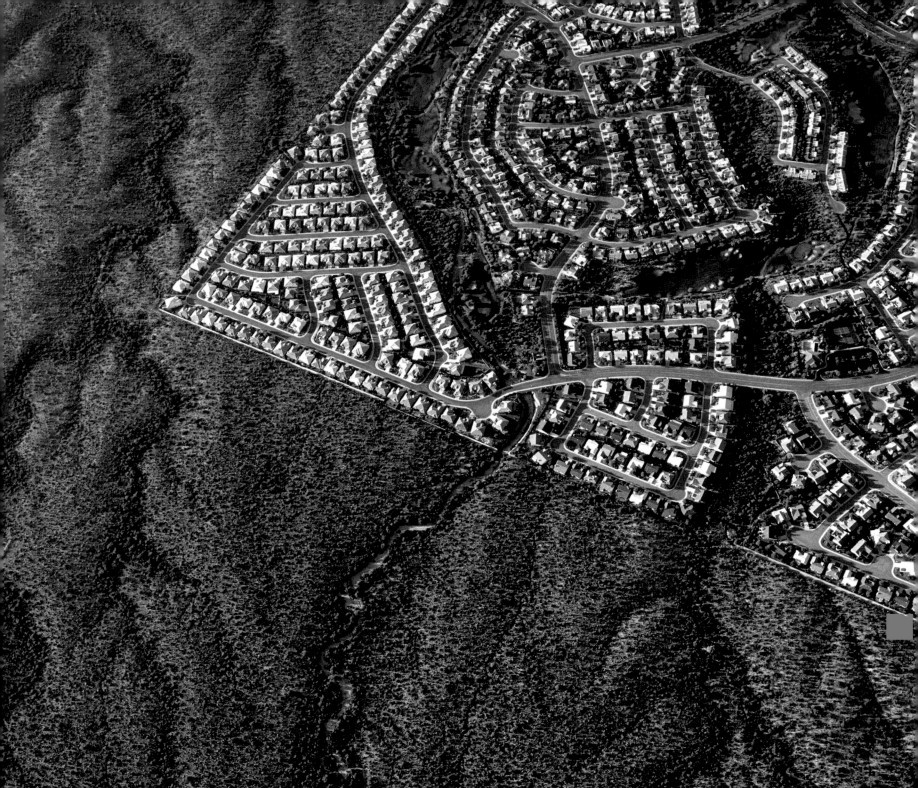

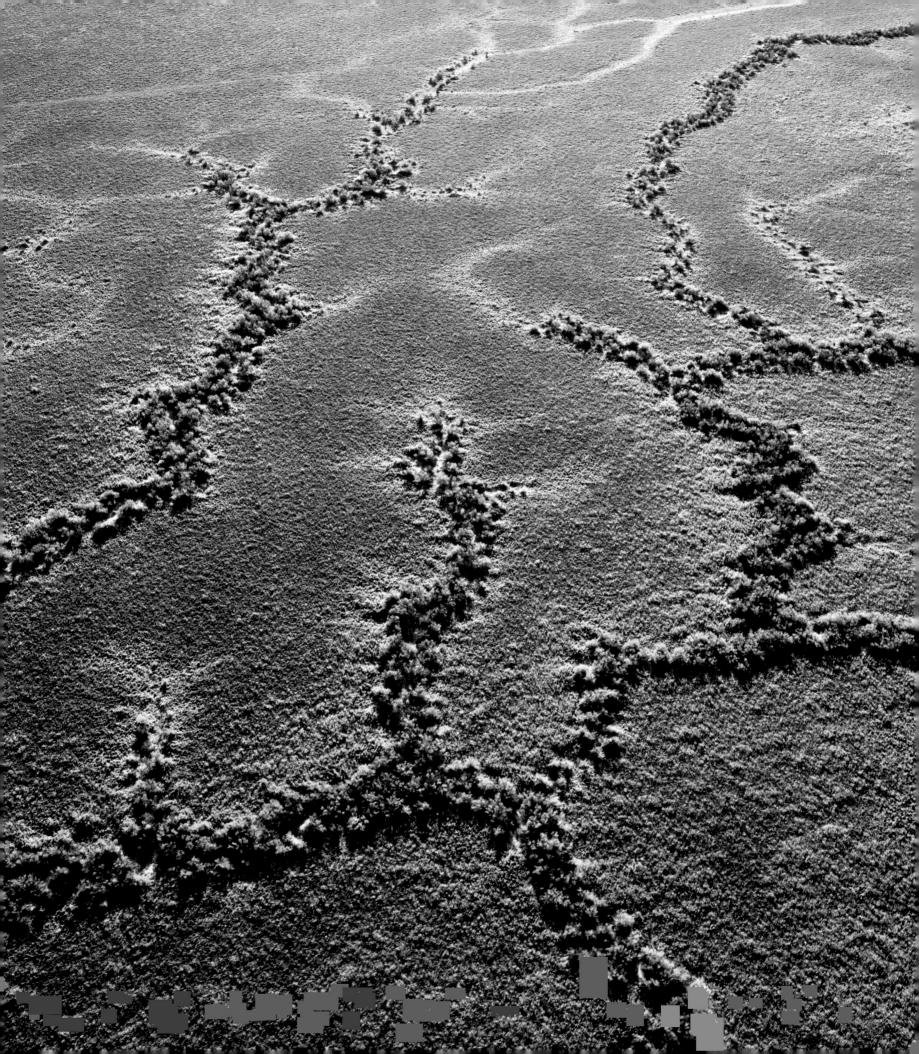

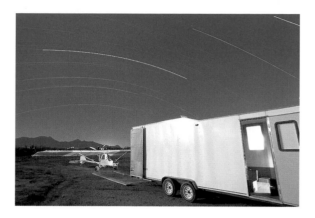

AT FIRST GLANCE, the trailer that carries my airplane looks like it might have a racecar inside. That's the closest it comes to resembling anything in the ordinary world. It's big, white and long, with doors on the end that swing open to let whatever is inside come rolling out.

If you take more than a first glance, you will discover clues to the trailer's true contents. It doesn't seem to be carrying much weight, certainly not a two-ton automobile. The proportions are slightly off: it's too long, too tall, and not quite wide enough. It looks vaguely homemade—finished out nicely, but boxy.

An airplane in a trailer is a design problem with no obvious solution, so most people just don't expect it. I stop short myself, sometimes. I'll be walking out from the supermarket, carrying blocks of ice for the cooler, and catch sight of my rig in the parking lot. How can the plane I know—the one that takes me above the highest peaks in the Rockies, bears me safely through lung-squashing turbulence, and ushers me into the sublime—how can that big, hardy machine fit inside that box?

My airplane undergoes a transformation as it unfolds. No tools, no helping hands—just seven minutes is all it takes me. The wings come off their stows on the tail tube and swing forward to get pinned in place on two struts, while the tail surfaces

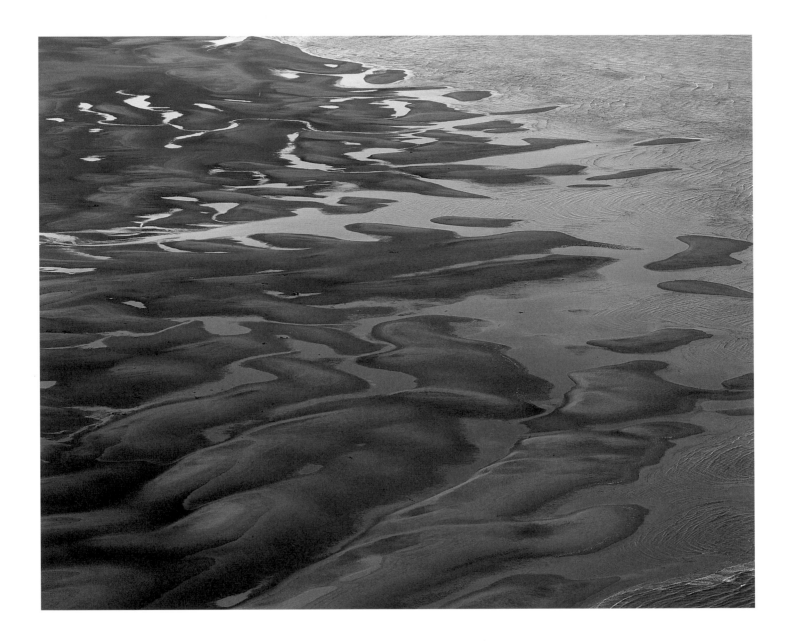

open down like a butterfly's wings. Folding allows me the luxury of keeping my plane at home in the driveway. But that's not the half of it. It also means I don't have to fly state-crossing distances in a plane intended for slow rambles. My home base accompanies me wherever I go. Fuel. Tools. Spare parts. Food. Dogs. It's a hangar on wheels.

Trailerability means I can travel the roads with everyone else. Only when I get to my theater of operation do I invoke the magic of flight. Not needing it for utilitarian purposes, I tend to use it judiciously. If storms threaten, or winds won't relent, or clouds turn the sky to milk, I have a safe haven until things improve.

It would be nice if the inside of the trailer were outfitted like an RV, with a little kitchen area, a fold-down bed, and tidy compartments for all the odds and ends—but it's not. It's a big empty box with bare wood walls. My airplane sits backward, tail at the forward end. Everything else gets arranged around it. Ramp-planks on the floor. Ammo boxes full of airplane gear

secured against one wall. Six fuel jugs strapped in a row along the other wall. And all the way up in the forward end are the makings of a quick-start household: folding camp-table and chairs, lanterns, sleeping bags, and a couple of crates full of supplies.

My Bronco carries a load, too. Extra spare tires, dog beds, snacks, books, maps, and music. It's the largest vehicle I've ever owned. It has four-wheel drive, high clearance, and lots of horsepower, and although it's fourteen years old and drivers of snazzier rigs eye me with pity, it growls with confidence even when fully loaded for an expedition.

Getting into Mexico with my airplane takes all the chutzpah I can muster. Each time I cross the border is different, but rarely is it a breeze. When I moved to Tucson and began traveling to Mexico for the first time in my life, I made notes during the crossings, thinking I could eventually learn every nuance of the procedure and get it down perfectly. Around that same time, I also believed that building clouds and sweltering humidity means rain is coming, that it always cools down at night, that it doesn't snow in the desert, and that the desert never has enough water. Now I think of border crossings the same way I think of the Sonoran Desert weather: anything can happen.

This afternoon has all the makings of an easy crossing. It's Friday, and we're going south to play on the beach. Yes, we have something unusual in back, but the truck is full of family life: wife, son, three dogs. I use every possible shred of rectitude to make it through.

At the immigration office in Nogales, Sonora, everyone must stop. It's going to take us at least an hour to clear all the hurdles since Holly and Orin need to get tourist visas, and it's the eve of a weekend. The line at the immigration desk trails out the screen door and down the sidewalk. We add our bodies to its length, and settle in for the wait, shuffling through our papers. Holly's birth certificate looks like a diploma, with its gold seal, calligraphic typeface, sepia-toned picture of a stately Wichita hospital, and two original inkblots from her newborn feet, tiny as lima beans. Orin's is less momentous, being from a

different time, but it shows an unusual birthplace. He still lives in the house where he was born almost fourteen years ago. The signature is a midwife's, not a doctor's. These details are lost on the man behind the desk as he scrawls his way through the immigration forms. He's looking for one thing: country of origin. When he's done, he levels his finger at me and says, "You?" I show him my visa with its recent date, and he waves us out.

Now to get the airplane through. We drive up to the ALTO sign, and are briskly motioned aside for special treatment. When the officer comes up to the window, I hand him my permit without a word. He scans it, and then flips it over. On the back are two stamps, one for the trailer and one for the airplane. He glances at me, then at the trailer, and then heads for the back, leaving two words hanging in the space between us.

"Open it."

The hinges groan as I swing the doors around against the trailer sides. I feel like I've just taken off my clothes. The man is standing with his hands on his hips, blowing a long unformed whistle as his eyes move around the cavernous interior of the trailer. Seen this way, my airplane doesn't look much like what it is. Its open seat is facing the door of the trailer. With no cowling to give it shape, this "cockpit" makes an odd nose for a plane. It's hard to tell how the wings would be arranged, and the engine is all but hidden. He steps up inside.

"*Aeroplano . . .*" he says to himself as he steps over the landing gear and walks up through the trailer between a wing and the fuel bottles. He lifts a cooler lid and peers inside, then zips open one of our duffle bags. His eyes come back to the gas cans almost right away, and he kicks at them with his boot. Every single one is empty.

"*¿Gasolina?*"

"*Sí, Pemex,*" I say, and point down the road where we both know a station is waiting. I hold my breath for his reaction. Other times I've been turned back—or hit up for a bribe—because I carried too much fuel across the border. This time I'm crossing empty to see if it's easier that way. Fortunately, my plane prefers unleaded automotive fuel to avgas, so I can refill

at any service station. It's one more happy intersection of do-it-yourself flying with over-the-road convenience.

The agent looks up at the engine, then at the fuel tank just below it. He likes how obvious everything is about my outfit, I can tell. The gas isn't going to be an issue. He studies the Temporary Vehicle Importation permit I gave him. When he finds the handwritten number, he asks me where it is on the plane. I step in close beside him so I can squat down and point out the metal identification plate on the fuselage tube. It's stamped with a dozen vital statistics about the aircraft, including my name and address as builder. He kneels to study it for a moment, and then turns to me.

"You made?"

"Sí, I made it myself." I wish I could elaborate, tell him more about the plane, and give him the honor of using his own language, but Spanish words flutter around in my head like restless pigeons, refusing to roost, and I sense he's near the limit of his English.

He arches his eyebrows and stands up.

"How fast?"

I move back to the open end of the trailer as I make a quick calculation.

"*Ciento kilómetros.*"

"How long?" He's pointing at the ceiling.

"*Dos horas.*"

He runs his hand down the smooth curve of the fiberglass pod beside the pilot's seat. The little door on it is latched tight. There's enough photography equipment inside the pod to stock a camera store. It would raise hard questions.

"Wait." he says.

He leaves the trailer at an urgent clip. I hear a burst of Spanish in the nearby office, and he returns with two more agents. All of them are young men, wearing wide black belts laden with the tools of their trade: pistols, ammo, two-way radios, handcuffs, and knives. None of them suffer from a lack of self-confidence. They ignore me as they stride up into the trailer and gather close around the open cockpit. Their banter is fast, excited, and incomprehensible to me; all three turn and glance at me briefly in the middle of it. The first agent is pointing all over the place: at the fuel tanks, at the gauges, then up at the engine. He thumps the camera pod loudly with his palm. I'm starting to feel queasy.

Quick as a blink, the man plops into the pilot's seat, lifts my helmet onto his head, and grabs the control stick. He works it around like a gearshift. Sputtering noises rise out of the huddle as the other two men back away, staggering with laughter. I can't help but join in; I think I'm passing the inspection.

I need to buy gas for the plane before we leave town, so at the Pemex station I pull up to an island of green pumps. Young men in rumpled uniforms move among the vehicles like waiters in a restaurant—there is no self-service. An older man leans against the pump I'm aiming for, his arm draped over it. I watch him in the right-side mirror as I line up the trailer man-door with his pump. He shows no interest in what I'm doing.

Orin wants to get out and stretch in this foreign country, so I ask him to help me get the fuel jugs ready to fill. He disappears into the darkness of the trailer, then feeds them out to me one by one. They're the color of empty milk bottles, and they give a hollow thunk as I line them up on the oil-stained cement. When our attendant sees what's going on, he jumps into action as though he's glad for something different. Gasoline shoots into the first big bottle in a thunderous torrent, brown as beer, and fumes spill out the top. I sweep my eyes around for lighted cigarettes, on instinct.

I glance at the octane sticker: 86. I wish it were higher, but this must do; nothing else is available. Gasoline is easy to be finicky about because it's so important. For a long time, I didn't want to use Mexican gas. It looked dirty to me, as though it hadn't been refined thoroughly. The idea of dangling my life from an engine drinking impure fuel made me cringe. But over the dozens of trips I made into Mexico, it slowly dawned on me that my truck never had any trouble with gas, and neither did my airplane the few times I had to replenish it from local

pumps. I eventually let go of my biases. On this trip, Pemex will power every flight.

Three hours later, the farming town of Caborca is behind us as the road climbs the last rocky hills before the coastal plain. We've turned off Mexico Highway 2, relieved to quit the harrowing pace of northern Mexico's most heavily traveled highway, where an interstate's worth of traffic squeezes onto what would be a pleasant back road in Arizona. Now Sonora Highway 37 follows the largest river in this part of the state—the Río Asunción—and where the road crosses the river, or sidles up close, I can see in the shine of headlights that it is white, sandy and dry.

After "La Y," where the road to Desemboque veers off the well-traveled route to Puerto Peñasco and makes straight for the ocean, we have only forty-two kilometers to go. It's 10 p.m., and Orin is asleep in back with the dogs. Holly and I are talked out. Ahead in the high beams, the ancient pavement looks as if it once took a hail of hand grenades, and no one ever bothered to patch it up. At first I try dodging the pocks; there is no other traffic. But soon the swerving becomes worse than the potholes. If I didn't have the trailer, I'd just clench my teeth and ramrod through. The Bronco is built for this. What it's towing is not, however. I ease up on the pedal. As the speed decays, I take time to peer out into the darkness. We're long past the endless vineyards, plots of cotton, and orchards of olive and pecan trees around Caborca. The desert has reclaimed itself from civilization. We're lucky there's any road here at all.

Up ahead, Desemboque throws its feeble light onto the curtain of salt spray hanging low in the sky. To the south—all is black. To the north—black. The glow of the little village is reassuring, but lonely too, as if it's is the last outpost of humanity. This is where Sonora meets the sea.

Holly is wide-awake with me as we reach the edge of town. The pavement crumbles to an end, and we creep down the dirt street, through swales and over mounds, the truck pitching gently as if we're already on the waves. There are few overhead lights, but every so often a house window glows with the color of whatever fabric is pinned up inside. The buildings look homemade, showing every stage of incompletion or disrepair. Empty window frames. Doors lolling off hinges. Unfinished cinderblock walls leading nowhere. Flattened cardboard boxes patching the side of a house. Sheets of corrugated tin sliding off a roof. A bare light bulb, weak and drooping from a post.

Fences of all sorts embrace each family's private turf. Thornwood corrals. Courses of adobe bricks topped with wrought iron. Rows of old tires, painted and filled with sand. Some yards hold the carcass of a truck or automobile whose model year predates my mental archives. There's a wheelless school bus collapsed on its belly like a cow sunk in mud, tarpaper covering the windows and a plywood sheet for a door. Is that storage, or does someone live in it? I think there's a cross in the windshield.

I see few vehicles that appear to be roadworthy, but I soon realize almost every house has a boat lying somewhere nearby. Each skiff looks the same as the next except for color. They're wooden, about twenty feet long, with four cross slats spaced from bow to stern. There's a deck in the bow, just below the gunwales, where someone might sit, and the aft end is chopped off flat, suggesting a mount for an outboard motor. I don't see any, though. No oars, no motors. Just empty hulls.

Holly has the heater running, but my window is down—our compromise. My arm feels damp as it slides through the heavy air. Smells of salt and old fish pour in over our laps. The engine is barely idling as we slowly advance, and I begin to hear the throaty hiss of surf. Beyond the last house, the ground falls away sharply and our lights fan into the dark void. I stop at the brink. This is truly the end of the road.

I back the trailer around so we're facing down the oceanfront street. It is three blocks long, and in the middle block stands a lone street lamp. The pool of light is as orange as lox, and it is full of dogs. Dozens of dogs. Calm, sitting dogs. No roving packs. No frantic gaggles around a bitch in heat. No barking. Just village dogs holding silent council at midnight.

They move aside when we pass as if they can hardly be bothered. For all the squalor of their surroundings, they seem unusually plump and content. We haven't seen a single human being. A tremor of strangeness ripples through the night.

None of my maps show an airstrip hereabouts, so I had been hoping to make an airplane camp by the ocean. But what I see doesn't look promising. To my right, a massive dune rears up just behind what seems to be a small schoolyard. The street drops off onto the beach right in front of me, too far below. I can't drive down there without a clear sense of how I'd get back out. Waves cut white and rhythmic through the darkness. The trailer's running lights seem out of place here, like a visitor from another world. I know so little about where I am that I decide I'd better look for something away from the village.

Back out on the pavement, I observe that the road inland descends a little grade. For the first three kilometers down off the rise, the road tracks absolutely straight and level. It occurs to me that I could use it as my airstrip: no houses, no road signs, and utility poles set well back. All I need is a place to pull off the road and set up camp. In Mexico, these turnoffs can be few and far between, and even then they are often too abrupt for my long, arthritic trailer—or they're gated off. But just before the road jogs sharply to the north, I see a manageable turnoff on the left. I park along the narrow shoulder, grab a flashlight, and go scout it on foot. The track leads back toward what looks like a dump, not for garbage, but for excavation debris. Or it might be a borrow pit. I can't tell with the flashlight. Either way, it will give us the privacy of a little distance from the road—a rare bonus under these circumstances.

Holly wants to spend the rest of the night in the back of the truck, where Orin and the three dogs have made a cozy den. I can't blame her, but that means the dogs will have to sleep with me in the trailer. The first two hop out eagerly, if a little bewildered by our strange surroundings. Racine, the oldest, raises her nose for a long probing sniff, then disappears to investigate. Gilly, her daughter, wastes no time finding a place to squat. It's been a long haul. Bucky has to be lifted down off the tailgate—

all eighty pounds of him—because spinal degeneration has made his hindquarters virtually useless. This will probably be his last big trip. Once he's on the ground, he drags himself off through the mats of dewy sand verbena that sprawl in every direction. I set out a bowl of water, then pull some pads and sleeping bags out of the trailer for Holly. She's got a fine bed made for herself and Orin in less than five minutes.

Now for the airplane. Fire up the lantern. Pull out the ramps. Open up the wheel blocks. Then lift and roll, like a huge wheelbarrow. In twenty seconds the plane is outside. I chock the wheels and throw a blanket over the engine and cockpit to keep the dew off. Less than a half hour after we pulled in here, I'm ready to bed down beside my dogs. I set the alarm on my watch for 5:30, hang it from the thermos beside my head, and zip my bag up tight. I'll be lucky to get four hours of sleep.

I awaken as bright yellow light fills the trailer. Oh no . . . I overslept sunrise!

I sink back into the warm nylon to take stock. I'm about to fly in a place I've never seen before. The most dangerous part of the flight is just ahead—unfolding the plane and taking off. I'm just now awake from not enough sleep, groggy. This is Mexico. I really have to pay attention to what I'm doing.

Twenty minutes later, I bring the engine to life. As it's idling to warm up, I pick up the tail and wheel the plane down the path and onto the road. Not a single vehicle has passed since I've been awake. There is no wind. The sun is five degrees above the horizon and I've already missed the best light, but at least the eastern sky is clear. It's time to go.

I circle once over our camp to see it in context. It was a good choice. It's not on the way to any houses or fields, and it's well off the road. Everybody down there should be all right until I get back.

From up here, Desemboque looks even more like a humble outpost than it did last night. It's nothing more than a brown smudge on the edge of the sea, pulling taut against the single gray thread that ties it to Sonora's interior—my runway.

Scanning the coast in both directions, I can see no other evidence of civilization. Seven hundred feet up now, I pass westbound over the thin line of surf to get a sense of the other two-thirds of this planet. The blue Gulf of California yawns down from the horizon as if the sky doesn't know where to stop. My boots out in front of me are vividly etched against the marine void, and I notice a sprig of sand verbena caught in my shoelaces, fluttering in the wind.

The air is warm and dry at altitude. This is what it will be like later in the morning on the ground, when the sun reminds the land that it is desert, and takes back the dew. At takeoff, in my triple layered flight suit, I felt steeled against the windblast of cold dawn air. Up here I'm a bit overdressed.

This is far enough out to sea. I bank gently around to the south, eager to see the real reason I'm here—the outlet of the Río Asunción, which gives Desemboque its name. Six kilometers down the coast from the village, the beach splays out into the ocean perhaps three times its normal width for a kilometer or two, then shrinks back to a thin ribbon again. In satellite photos, it's a mere bump in the strand, but from my height, it's a serious stretch of extra real estate. I've never photographed anything like this before, and I'm excited to go to work. Five minutes, and I'm there.

Driftwood is nowhere to be seen on the wide expanse, save for a single timber as black as a puncture in canvas. Thin lines of waves, broken down from the shallow surf, wrinkle around the shoals like aging skin around a belly. From the look of the dark wet sand, high tide came sometime in the last six hours. That may be why the ocean seemed so close as I stood at the edge of Desemboque last night. Now, the water has pulled far back, leaving tide pools strewn among sandbars for hundreds of meters out to sea. The entire scene is seductively smooth: the aerodynamic curves of the little beach islands, the graceful lobes of the sea, the seamless shades of color from deep water to drying sand. My eyes caress these shapes and hues with a passion I usually feel only for sky and cloud; seldom does such visual purity appear below the horizon. But this morning, all

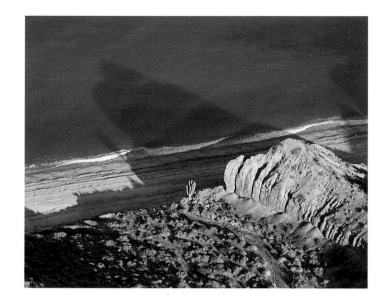

seems in concert: the intercourse of land and sea below is mirrored overhead by the organic forms of cirrus blooming out of the gulf to the west and spreading toward the sun. I circle lazily, aimlessly, adrift in a spectacle so embracing that my mind is purged of any notions of self or space. I am camera-sand-sea-sky-cloud-everywhere.

The cornucopian river channel draws me out of my reverie. This is a mouth if ever I saw one. On either side of it, the dunes are carpeted with heath and stretch unbroken as far as I can see. But here they are split wide open, and water has recently coursed far inland, then back out again. The sandy bottom lies wet and braided with rivulets. Only a couple of kilometers in from the shore, the narrowing ribbon disappears into a tangle of brush-covered meanders. After that, the only thing that tells of its life as a river is a stripe of slightly darker green vegetation trailing off through the desert haze toward Caborca. Twice each day, a tidal bore pushes up into the dry mouth of the Río Asunción, as if to wet its lips and keep hope alive.

Desemboque is named for this mouth. The word comes from the Spanish verb *desembocar*, to flow out, which in turn comes from *boca*, for mouth or opening. Standing in the village, you would have no idea why it has that name, and if you had to walk to the river, it would seem pretty far away to warrant it.

But with some height, it becomes clear that there's quite a distinctive bulge in the land here: a modest delta for a meager river.

Sonoran place names are mostly Spanish, with a precious few harking back to indigenous languages. The source of the name of Sonora itself is mysterious. It may be a corruption of the Spanish title for the Holy Mother, *Señora*, or it may be a derivation from the local Opata tongue. The Catholic influence is no coincidence. It appears repeatedly in place names—not least, this river. The Latin *assumere*, at the root of Asunción, means "to take to oneself." In this context, it alludes to the Catholic doctrine of Jesus' Assumption of Mary into heaven. But it also gives a wry secular twist to the river's name. Several hundred deep wells in the farm country around Caborca allow farmers "to take to themselves" the water underlying the Río Asunción, ensuring that it never flows on the surface anymore—except during flash floods.

I pull the power off and let the plane glide. It is buoyant in the thick air, reluctant to give up its altitude. The twang of salt rises in my nostrils as I drop in low along the water's edge. I feel safe. The breeze is light and friendly. The engine is running smooth and easy on a diet fat with oxygen and Pemex. I could land anywhere on the beach, at a moment's notice if I had to. And—worst case—camp is only a five-mile walk away over flat terrain. There isn't a soul in sight. A thrill shivers through me. I am free, electrified with discovery.

I take up a course parallel to the shore and slide out across the waves. From a few meters overhead, they look as though they're made of light, the way they refract and color the shallows. I weave from side to side over the infinite array of shapes forming, rising, cresting, breaking, and sheeting over the sand. They are always moving, as I am always moving, and the kaleidoscope of motion stirs up a harmless vertigo. I drop my left foot down into the air beneath my seat. I'm inching lower over the water, tracking an endless windrow of froth. I'm not thinking anymore. I am purely as I intend.

Cold shocks through my ankle, and I pull up from the water on raw instinct, trading the blur of motion for the clarity of height. The ocean falls behind me as the engine makes good

its full-throttle crescendo. In seconds, I am a hundred meters in the air, banking toward the river. My boot is dripping, the verbena gone.

The coast begins a gentle curve right under me and sweeps a pure arc all the way to Cabo Tepoca, forty kilometers to the southeast, where I can see an abrupt change in the landscape—mountains at the sea. That will be our next camp. I could fly there in a half hour, but the intervening emptiness forbids mere stunts. There aren't any roads along the coast—not even close—so we'll have to go the long way around, retracing our route to Caborca, then back out on forty-eight kilometers of dirt road to the cape. The day holds much in store. I lean the plane around so I can find my trailer, tiny white molecule of home.

I hit the kill switches, unlatch my harness, lift off my helmet, and step out of my seat—all in one fluid motion. Gravity seizes hard. The land is gigantic around me, a world under a microscope come to life. I'm no longer the free-roaming eyes above the eyepiece. I'm part of the specimen, moving slow as a protozoan.

"*¡Buenos días!*" Holly is walking out from the shade of the trailer. "How was it?"

"I got off late, so I missed the best light for my pictures, but the flight was superb. It's definitely an ocean out there. Couldn't even see the Baja. How'd you sleep?"

"Great, until the flies started. Hear them?"

Two hours of engine noise has fooled me into thinking this is silence. I listen deeper. The feathery buzz wafts on the air from nowhere, everywhere. As if on cue, one particular piece of it hits my lips, and starts crawling. The tickle is savage, and I'm not one for amnesty. Before I can think, I've slapped myself across the mouth.

"Welcome to Desemboque." Her smile is devilish.

Orin found them first. He was up and out of the Bronco shortly after I took off, eager to put his BMX bike to the test in such unruly terrain. Across the road, pedaling trails far back into the thickets, he had come upon a wasteland—heaps of white clamshells everywhere. The smell, he said, was like death

itself. When the flies began arriving at the trailer during breakfast, Orin knew exactly where they came from.

I'm an old hand at deferred gratification, probably thanks to a host of godly ancestors who kept one eye fixed on heaven their whole lives. I choose a campsite not for its immediate earthly pleasures, but on its merits as a portal to the sky. This odd view of things hinges on one key experience, of course. Flying transforms a dreary camp into the vortex out of which an entire new world springs to life. It dissolves boundaries, ruptures small-mindedness. I've undergone the metamorphosis so many times that I almost take it for granted. It affects how I see things when I'm on the ground, and I normally don't have to explain it or make excuses for it since my dogs are the only ones I take along on these trips most times. They don't care about bleak surroundings and vortices and boundaries because they have the simple animal joy of uncommon adventure.

But Orin and Holly are not impressed. They are going to have to fly.

I set up a low orbit around our little base, and Orin points out the piles of empty shells he stumbled upon. I hadn't noticed them before, but now that we know their grisly secret, we're both amazed to see how many there are and how far they go. White mounds peer up through patches of brush all the way to the dunes. This has to be commercial offal. Our camp is doomed. Over the intercom I tell him I've read how Indians used to camp along the coast and make bracelets out of shells they harvested from the sea, and how shell jewelry turns up in ancient ruins all over the Southwest. We're both thinking the same thing . . . maybe from here.

We double our altitude and then fly over to take a look at the village of Desemboque. It is alive now with people moving in the yards and turning boats over. A lone truck is crawling through the streets. Its cab is old and ruddy and bulbous, like the head of an ant. It has no bed, just a rusty steel skeleton for a thorax, and it's dragging a boat behind it toward the sea like a pupa to the nest. As it nears the water, two men dressed in white cut the boat loose from the tow and walk it into the waves. This could be Morocco. Spellbound, Orin and I watch them hop

into the hull the moment it is free of the sand, and white froth blooms off the stern as the outboard motor starts up. One man is standing in the bow, wielding a long pole to keep the keel pointed into the waves. The man in the stern is sitting bolt upright, studying the action to the fore. He seems to be hesitating. Suddenly the water behind the boat explodes and the prow surges into the breaking waves. The man in front is on his knees. They are at sea even before the water behind them has healed from their passage. As the boat takes up a course angling away from the shore, we fly a slow arc across its bow and wave our arms. The ocean is green-black under us. Neither man waves back.

I head south toward the river mouth, hoping to give Orin a little field geography lesson. But we're hardly past the lighthouse when he nudges his microphone close to his mouth and points down across my legs.

"What is *that*?"

As soon as he's spoken, I spot it. A long brown cylinder is lying parallel to the beach, just above the high water line. It has a couple of bends, giving it a slight "S" shape, and its smooth contours are broken by ragged pits. The sand around it is a dark smear, riddled with tracks. Trails seem to converge on it from every direction, especially the village. I'm circling almost unconsciously to give us more time to stare.

"My God, it's a *whale!* "

"Oh guhROSE!"

"Look, there are dogs eating it!"

Orin's groan comes through the earphones right into my head.

"I think I'm gonna be SICK!"

I ease out of our gawking turn and throttle back. I believe the tour is over. Camp is just a few kilometers away, and I set a course for it. Out of sight of the carnage, the fresh sea air begins to have its effect. Orin makes it back to the ground none the worse for his second grim discovery of the day.

It's Holly's turn to escape from the buzzing hordes. We climb up through gentle burbles of warmth, then coolness, then warmth again; the sun is beginning to stir the air. Holly has a

9

special distaste for any kind of turbulence, so our flight together is short—but duly impressive. There is now nothing I can show her within fifteen minutes of Desemboque that will surpass the sight of a half-eaten beached leviathan.

Breaking down camp seems to take three times as long as setting it up—when it's just me and the dogs. Holly, however, has been busy in my absences, and I sense she is anxious to move on. I am too. Being camped near a road with something as eye-catching as an airplane makes me feel vulnerable. Whoever passes by is free to stare, to stop, to ask questions. I can handle most visits pretty smoothly, and the worst of it is lost time. But this is Mexico. I can't say I'm from "just over the mountain, near Tucson," as though I'm practically a local. I'm not. I'm a foreigner, and I can't do much with Spanish. Holly says no one has stopped so far, but it's getting later in the morning, and this is the only road out of town. I start my little game of seeing how fast I can make the airplane disappear into the trailer.

I've gotten no further than removing all the safety pins when I hear the rising hum of an approaching vehicle. On my stepstool, I can see it coming fast up the straightaway out of town. Its headlights are on. The Doppler effect makes it sound as though it's accelerating, but I know from experience that this can hide the first signs of slowing down, so I watch it closely to gauge its speed. I freeze when I realize the vehicle is an army truck, full of soldiers.

"Where is Orin?" I call out to Holly.

"He's off on his bike somewhere."

"Aw, shoot. Okay. Will you get my papers out of the truck? And bring my Spanish dictionary."

The men in back are standing, lined up along the waist-high canvas side panels of the truck bed, three or four meters above the road. Their rifles stick up above their heads at odd angles, pointing into the sky. The colors of this military unit are almost beautiful, a simple spectrum of green, brown, and black.

Holly is crossing the open space between the trailer and the airplane. The truck is almost abeam us. This is the instant it will

start to brake if it's going to turn in to our camp. I can't even count how many soldiers there are.

Holly lifts her hand tentatively and offers a little wave. Arms erupt above the rifle barrels, flailing in the blue. The truck is not slowing down. I see open faces, gleaming smiles. Holly and I burst out laughing, waving back as hard as we can.

The sun is sinking fast when we roll up to the ocean at Cabo Tepoca, and I can't afford the time to experiment with a beach takeoff, so I go with the sure thing: the dirt road leading up to the parking area. Orin is even happier to be out of the truck than the dogs are, and he grabs his plastic snowsaucer and runs for the dunes. Holly starts putting together a sandwich that she's been needing since we left the pavement two hours ago, and calls after Orin that she'll meet up with him later. Racine and Gilly have some serious trash reconnaissance in mind, while Bucky pulls himself a short way from the rig and collapses into the forgiving sand with a sigh that makes my heart ache. It's been three solid hours of jouncing torture. I'm not so sure he's glad he came along.

A little audience gathers as I get the plane ready for take-off. Unlike Desemboque, Puerto Lobos seems to be a bit of a destination. The village nestles in the crook of Cabo Tepoca just inland from the lighthouse, where the rocks hook out into the sea far enough to make a sheltered little cove. We're at the public beach north of town, among a few cars and vans with Sonora license plates parked around in casual disorder. The scattered families are probably down from Caborca for the weekend. I make a little conversation with a friendly fellow who seems happy to indulge my language handicap while I unfold the plane. He's heard of these things before but has never seen one up close. He says there's an airstrip out of town a ways, up on the bajada. I invite him to watch me take off right here behind the trailer— I'll be in the air within a hundred meters, I tell him.

Quite a bit less, as it turns out. My first seconds off the ground feel like I'm launching for outer space. The few precious details of survival loom large just now, and I'm frowning with

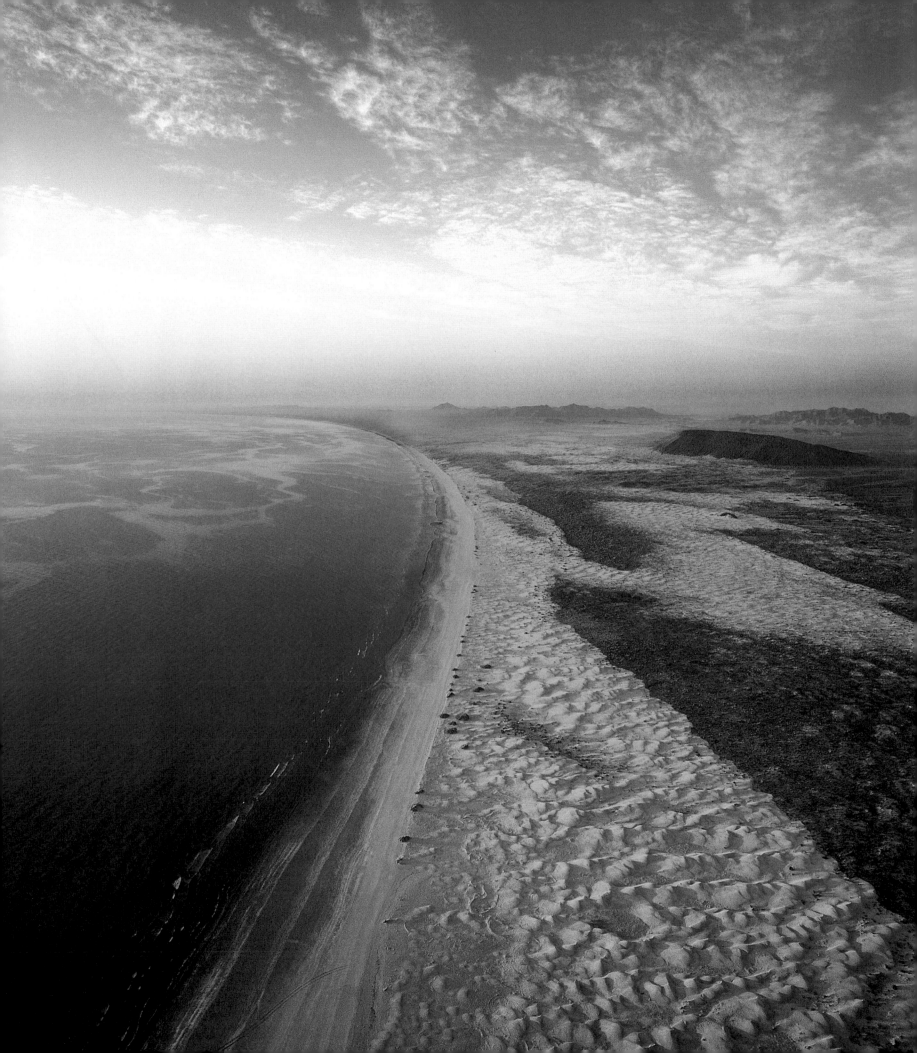

intense concentration. But behind the mask, I am serene. I have a watcher inside of me who is immune to all danger. I watch my rapid ascent change the world. I watch the way the horizon is drawing back like a vast iris, gently opening. I watch nearby mountaintops sink into the earth, while beyond them distant peaks rise up in a slow, revelatory circle-dance as I climb higher and higher. The land around me is showing itself with disarming candor, and my thoughts fall silent in the presence of so much nakedness. I'm losing touch with my singularity, my shrunken little life on the ground. The sky has become a boundless cosmos, alive with depth, as if it can quicken me out of the grip of simple location, into its realm of being everywhere at once.

A thousand meters in the air, I slide the throttle back until the engine is purring. Its tone tells me it is at ease. I feel as if I could practically step out and walk alongside the plane, the sense of motion is so slight. I drop both feet down off their little heel pan and let them dangle in the wind below my seat. Scooting forward, I lean my upper body out into the generous cradle of my loosened shoulder straps. The plane is balanced and steady, the air like silk. I strap the control stick to my knee and lift both hands up into the airstream as if I'm palpating the flanks of an invisible creature. The stuff that lets me fly rushes softly through my fingers. I am in the mystery.

The cape marks a pronounced change in the land's character. North of Cabo Tepoca, the beach is wide, flat, and white. The water is shallow far out from the shore, and its color reminds me of the luminous aqua hue of tropical seas. But southeast from the point, the terrain begins to rise and press close to the water. The beach turns into a narrow gravel strip barely twenty meters wide that slopes down to the waves at a steep angle. It has a dun cast that deepens to almost black where it's wet. From altitude, the strand looks like a perfectly engineered road right on the edge of the ocean, but in fact it is wild and untrod.

The most remarkable feature is the cliffs. They rise vertically out of the beach a hundred meters and higher, forming an imposing wall along the ocean. This is not an isolated occur-

rence; I can follow the cliff line with my eyes far off to the southeast, where the next cape intrudes on the sea. That one is no mere stone toe poking in the water like Cabo Tepoca. It's a whole mountain, and it's where I'd like to photograph tomorrow morning if I can work up my nerve for the journey.

The light on the cliffs has turned the color of candle flame, and it is waning fast. I roll the plane through a one-eighty to take a look out west. The sun is poised no higher than its own diameter above the horizon. Higher up, the sky is awash in a delicate pink glow. There isn't a cloud west of the zenith. The sun itself is a dull ember nestled in a bed of blue air, which grades almost seamlessly into the sea. The horizon is featureless, and it's tempting to think of mainland China as the next dry ground to the west, but I know that the Baja peninsula is out there guarding the Pacific. With full tanks, I could make landfall in about an hour and a half. The thought of crossing so much open water makes me squirm in my seat.

I can look right into the sun now without squinting. There's a mountain silhouetted against its bottom edge—Baja after all!— but the top of the disk has spread out like an anvil. Its shape is changing as I watch, like the blob in a lava lamp, and in less than two minutes, it is gone. I've never seen this happen over the land.

My scouting for tomorrow's flight is finished, and I've gained a photographic toehold here. I have one last task before I can lay down my wings for the night: to test the beach as a runway. Theoretically, the packed sand of the upper beach ought to be a good surface, especially since I have soft, fat tires on the two main wheels. But I've never actually landed on beach sand before, and I feel my adrenaline rising as I circle, looking for a good spot. It's at times like this that things can turn ugly, quick as a rattlesnake strike. I think of the worst that could happen, just to make sure I'm paying full attention here: the wheels might gouge into the sand, rather than roll across it, and the plane would flip upside down in a crumpled heap before I knew what happened.

I override my imagination and calm myself down. I know how to handle this. I learned a strategy years ago for dealing with muddy airstrips when I flew bush planes up on the Navajo

Indian Reservation, and it will be just the thing for this situation: come in slow, but with enough speed so I won't need to land. Stabilize a meter or so above the ground, and when I'm ready, carefully lower the left tire onto the surface. Be ready to lift it back off as soon as it touches. Depending on how it feels that first moment, try it again, only let more of the plane's weight down this time. If there's any doubt as to the quality of the surface, don't commit. Pull out and fly away.

There's a string of thatched ramadas up the beach from where I parked the trailer. One or two have families clustered around them, so I choose a stretch beyond the huts where the beach looks uninhabited. It will be a good place to camp if the sand proves planeworthy.

All lined up, everything steady—I'm going in. Darkness is falling, but the sand is white and my pupils are dilated in the dusk, drinking in the feeble light. I level out close above the beach and take stock. I can see everything. The sand is clean and unmarked, empty of rocks. My speed feels modest, like a bicycle sprint. There doesn't seem to be any wind at all. I dip the left wing enough to touch the tire to the sand. The plane yaws a little with the drag of the light touchdown, but I feed in enough opposite rudder to balance it out. I bring the wings level, lifting the tire up off the sand. Nothing squirrelly at all. Down again, let more weight on this time. It feels good; my fear is gone. Come back up, steady it out, now pull the power off and let the extra speed drain away, and finally settle it onto the sand. I'm motionless in seventy meters. Perfect.

Holly meets me halfway as I stride down the beach to get the truck. Racine and Gilly are by her side, Bucky is back where I left him an hour ago, and Orin is still ripping around in the dunes. I take a roll with the dogs in the sand, feeling almost giddy with the success of my landing, the discoveries of my flight, and the prospect of a night on the beach under the stars.

It takes me over two hours to do all my post-flight chores, so I'm glad Orin is tuckered out from his sand escapades and Holly has a book to read. Even the dogs give up on me and retire to their pads. This is when I pay my dues: refueling and checking over the engine, propeller, and airframe for any signs of trouble. If something needs tending to, now is the time; I sure won't feel like doing it at five o'clock tomorrow morning. I unload all the film I shot on the flight and write it up in my logbook, then load fresh film into the camera backs and carefully arrange all my gear in the camera pod for the morning's flight. I tie down the wings, strap the controls tight in case of night wind, and sit down beside Holly just before ten o'clock.

"Want to go for a walk?" she asks, flipping her book closed.

"Sure. Orin's zonked. He won't even know we're gone. Let's go."

Racine and Gilly can pick those last two words out of any conversation. They're up and shaking off their slumber even before we've pulled on our jackets. I give Bucky a soft assurance about our return and sneak him a biscuit. Holly snuffs out the lantern, and the night envelops us.

Down at the surf, we turn north to walk along the water in the darkness. The ocean is a black void, save for the lights of a few commercial fishing boats far out in the gulf. The western sky is glittering with stars, and a noticeable cone of zodiacal light glows up out of the horizon, towering faintly into the heavens.

On most of my outings, I'm alone in the hinterland, and I often can't even use a telephone to talk to Holly. It can go days between calls. During that time, she has no idea of my welfare, and I have no one to reach out to. My dogs are heart-warming companions, but they can't sympathize much with my frustration over a burned-out voltage regulator or my excitement at finding a prehistoric rock alignment. Having Holly here is a rare luxury, and I feel peaceful and complete by her side.

I open my eyes to a sky brighter than stars but too dim for color. The cloudless field wavers between feeling close, like the inside of a milk bottle—and feeling limitless, like a galactic fog. I gaze into the void for a few moments, not yet fully returned from the land of my dreams. Then a pulse of excitement washes through me as I remember where I am and what the dawn will bring. This is a moment of sweet simplicity, when last night's preparations are ripe for plucking. I rise, I fly.

13

The cliffs are about thirty meters off my left wing as I track southeast along the coast toward Sierra Julio. They rise and fall with a mesmerizing rhythm, and I move in closer to intensify the sensation; soon I feel as if I'm flying along the saw-tooth spine of a gigantic sea serpent, hoping it stays still while I'm so near.

I study the exposed walls for signs of their constitution and find them as revealing as a vivisection. Rocks of all sizes are peppered throughout the adobe-colored earth, as if frozen in mid-tumble. Lower down, I can see some different-colored stripes, and the stratification reminds me that this material was not plopped here in one great cataclysm, but laid down layer by layer over vast spans of time.

Up ahead, the low sedimentary bluffs are being upstaged by a growing mass of light-colored rock. I add a little power to begin climbing for the rough country to come. The sun spreads light over the rugged summits and throws their shadows out to sea. What happens to shadows falling on the ocean? If its sur-face were a desert plain instead of water, the dark line would siz-zle across the sand, sharp and jagged as a seismograph trace. But as it is, it's practically invisible. Instead of an outline of the mountain, I see only intricate texture, as sapphire ridges of water cross through each other in a soft, unending quiver. This is a new spectacle for me, and I work up a sweat with my camera as I dis-cover compositions I could only imagine before this moment.

I soar along the mountain crests as they glare with the harsh, clear light. They're all but barren, dotted with clumps of scrub in the crevices and pockets where scant runoff might col-lect. The only plants I recognize are ocotillos. I can see their wild-flung spindly arms swaying as breezes begin to stir in these heights. A cluster of weathered rocks on one of the peaks is streaked with white, and I look carefully for raptors but see none. I am alone in the sky.

The immensity of my surroundings overwhelms me. The trackless sea, with no land on its horizon and no boats in sight . . . the sierra rumpling up below me . . . the basins corru-gated with gullies. I haven't seen a single person since passing

Puerto Lobos on my way out this morning, not even any evi-dence of humanity.

The engine's drone is the voice of a contented machine. I review its modest needs: fuel, fire, air. The simplicity of its sys-tems are a comfort to me, but they also remind me of its frailty. I study its gauges intently, as if I can feed it encouragement through these little windows to its soul. My life is hanging on this engine. Should it fail, even if I could make a successful emergency landing on the narrow beach, my ordeal would have just begun. I'm out of radio range. Holly knows only that I went south. She doesn't know this place exists. I have a bottle of water, an energy bar, a few survival items. For a split second, I catch sight of the coast as it would look if I had to hike back to civilization. I would need most of the day on the loose cob-bles—that is, if I survived the touchdown. My little epiphany drains the thrill out of my splendid isolation and douses my passion for exploring. It is time to go back.

By the time we reach the pavement far inland, the sky west of Caborca is blazing with the low sun, and its colors fill me with nameless emotions. I'm often airborne at this time of day, but tonight we need to make Tucson. Orin's face is glowing in the last light as he reads the liner notes of the CD he's listening to on his Walkman. He's persuaded his mother to give him the front seat; she's snuggled in back with the dogs. I smile when I see the title of the CD. *OFFSPRING*. The graphic design of the cover looks like an alien invasion on LSD. Little hissing con-cussions leak out from his earphones at a beat faster than any-one could dance. I'm amused that the music has lyrics, and grateful I don't have to hear them.

When Holly and I married two years before, we set out on an adventure together. I came with three dogs in their sunset years. She brought Orin and Shea, a son and a daughter, 11 and 15. I suddenly had a real family, and I arrived just in time for adolescence. This is new territory, beyond the pale of tradition. Our bond isn't given to us by biology, so it must be crafted more consciously. I'm not always sure what I have to offer them.

Many times I wonder: what will Orin remember of our little blended family when he's my age?

"We're going to have to ask you to step out of the vehicle, please." The U.S. Customs agent has a German Shepherd on a leash. It's whining to go to work on us. Holly is sitting up front now, none too happy about the midnight search. Orin is fast asleep in back along the tailgate. Bucky is stretched out beside him, the picture of contentment. I walk around to lower the rear window and nudge him gently.

"Orin, we have to get everybody out."

I give him a chance to wake up while I open all the trailer doors. Another agent is walking around the outside with a mirror on a long pole, shining a flashlight beam up into the undercarriage, looking for contraband. Then she goes inside, high-stepping over all our stuff, tapping on the walls and poking in our duffles. I wince when she opens our coolers and rustles through the bags of cheese and cold cuts. I know what's coming.

"You can't bring meat or dairy products across the border." Her tone is flat.

"We brought them from Tucson just a couple of days ago." I'm trying to be flat.

"Doesn't matter. You can't bring them back into the country. We've got trash cans right over there."

I start gathering up the packages while she finishes rooting around. I resist the urge to comment on their choice of inspection targets. I know they're under a lot of pressure. When I step out of the trailer, Orin and Holly are standing against the wall of the Customs pavilion with Bucky, Racine, and Gilly on leashes so they won't take off after the police dog. It has to be humiliating for the dogs, waiting to see their own beds ransacked by this single-minded zealot.

To distract them, I give them a whiff of what I'm carrying, then hand it to Orin.

"We've got to get rid of this stuff before we go any farther, Orin. Why don't you give these guys a little feast?"

He loves to hand-feed the dogs, and wastes no time zipping open the plastic bags. He kneels down as they press close

around him now, tails wagging a whole new mood. The dogs know this is rare booty. Slice by slice, the turkey pastrami and provolone cheese disappear down three hungry gullets.

The timing is perfect. They don't even notice big Shep sniffing through their lair. He walks all over the back of the Bronco, then up on our seats, the center console—everywhere. The handler jerks his leash often, steering him around with quick little sounds. Finally he hops out and the agent calls over to us.

"All right, you're good to go!"

Then he notices what Orin's doing. I see the trace of a smile pass across his stern face as he calls out once more.

"You've got some mighty well-fed dogs there!"

Nervy of him. I'm about to flip back a dog-lover's answer when I hear Orin mutter in a voice hoarse with sleep and early adolescence, "Nothing like the dogs of Desemboque."

"ORin!" Holly and I shove his head down into the mass of fur, his snickers almost lost in the smacking of lips still polishing off a week's worth of lunch.

Shaken down and turned loose, we roll out onto the streets of Nogales, Arizona. The atmosphere of the town shifts abruptly as the border recedes behind us, and I brace for the inevitable wave of culture shock.

I can't imagine doing this work of mine if I lived in Mexico. Many of the people I've seen in Sonora seem barely able to afford food and clothes, let alone buy the niceties that I create to fund my existence—fine prints, magazines, and books. Those little rolls of celluloid tucked away in my film cooler wouldn't count for much if I weren't going home to a privileged life in the richest country in the world.

Interstate 19 opens wide in our headlights. Its clean white concrete, crisp markings, and shoulder wide enough to be an extra lane seem lavish after the balance-beam roads of Mexico. I slide my seat back and set the cruise control. The family nestles in the darkness around me as Tucson's light fills the sky ahead like a bonfire.

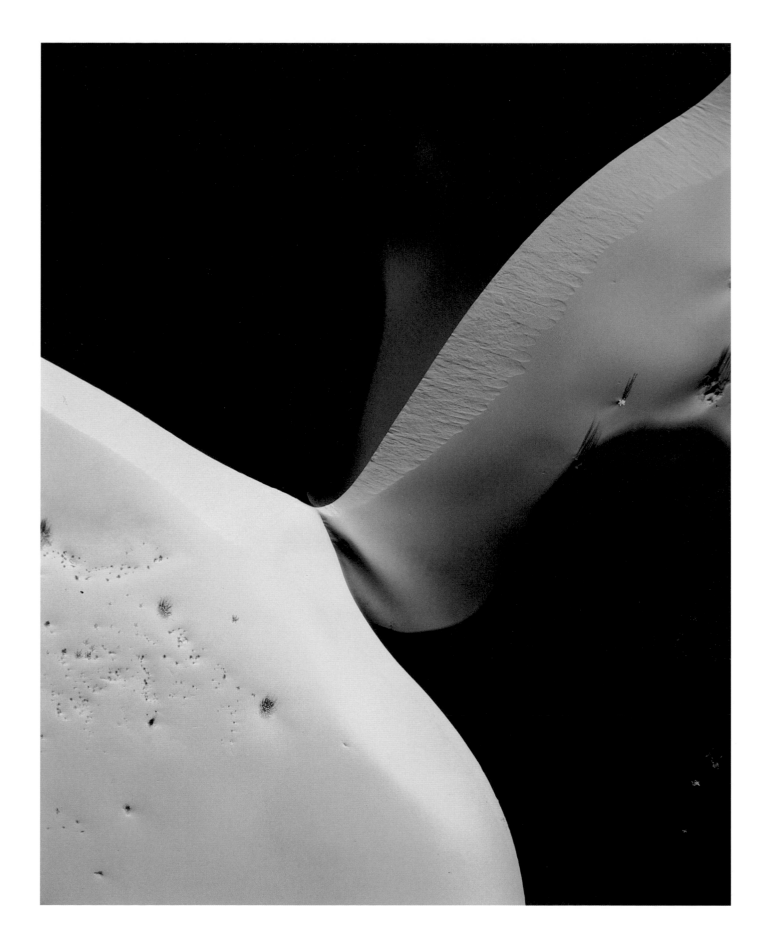

Star Dune in Gran Desierto, Sonora

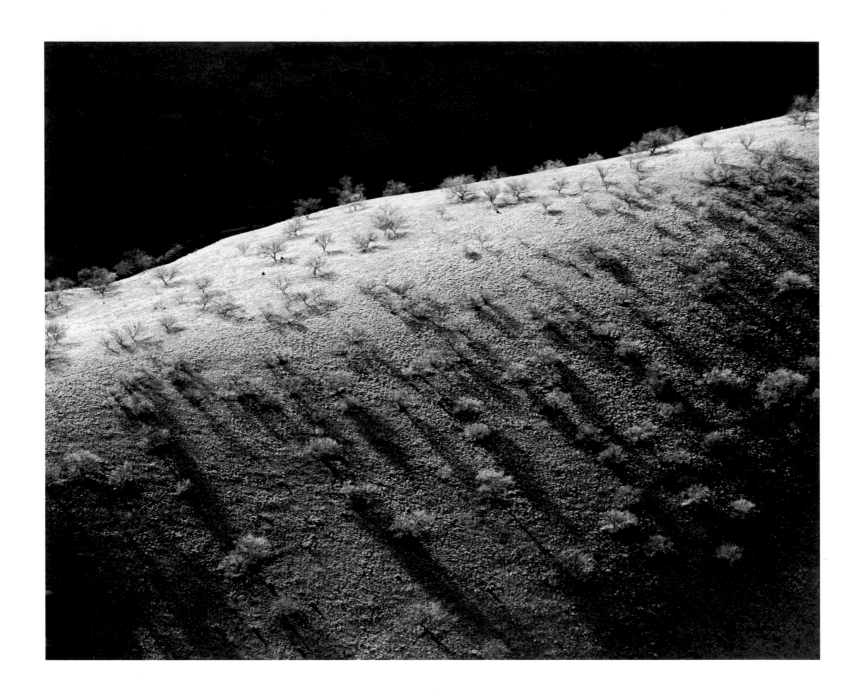

Mexican gold poppies, Patagonia Mountains, Arizona

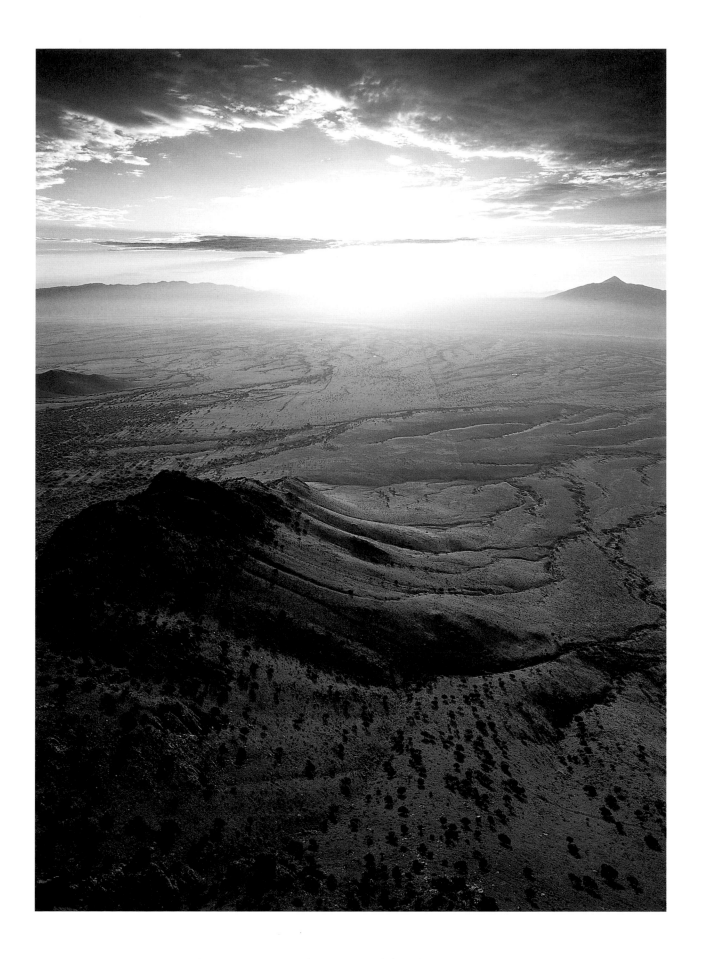

19

Huachuca Mountains and international boundary, Arizona-Sonora

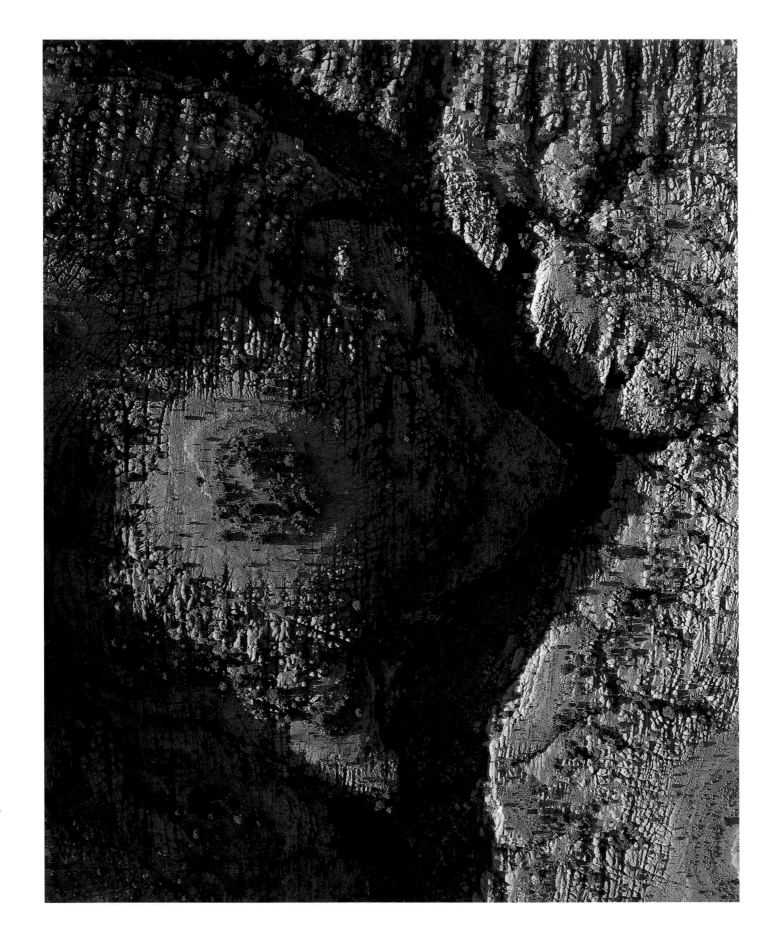

Eroding knob and canyon in Aravaipa Canyon Wilderness, Arizona

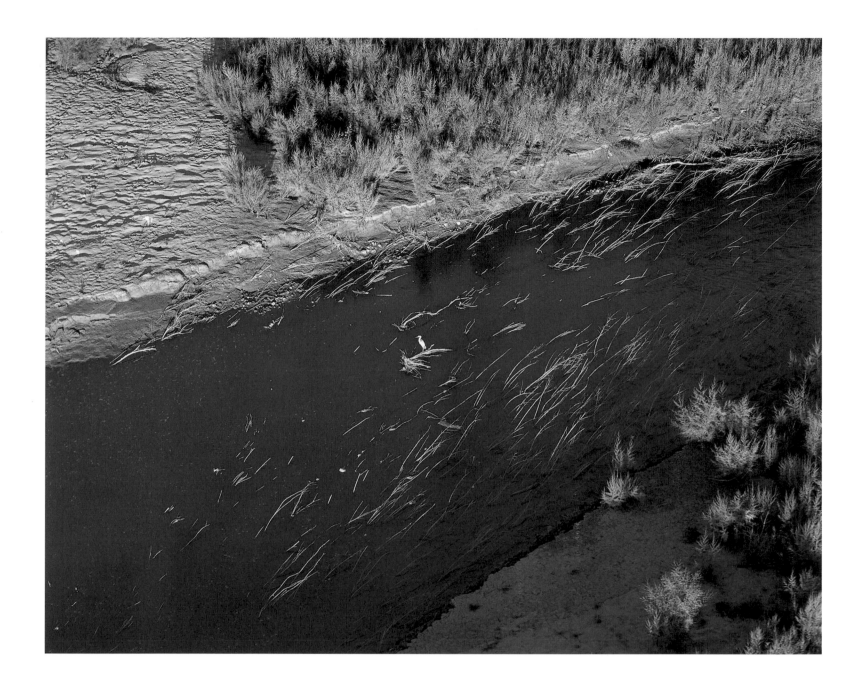

Gila River, San Carlos Indian Reservation, Arizona

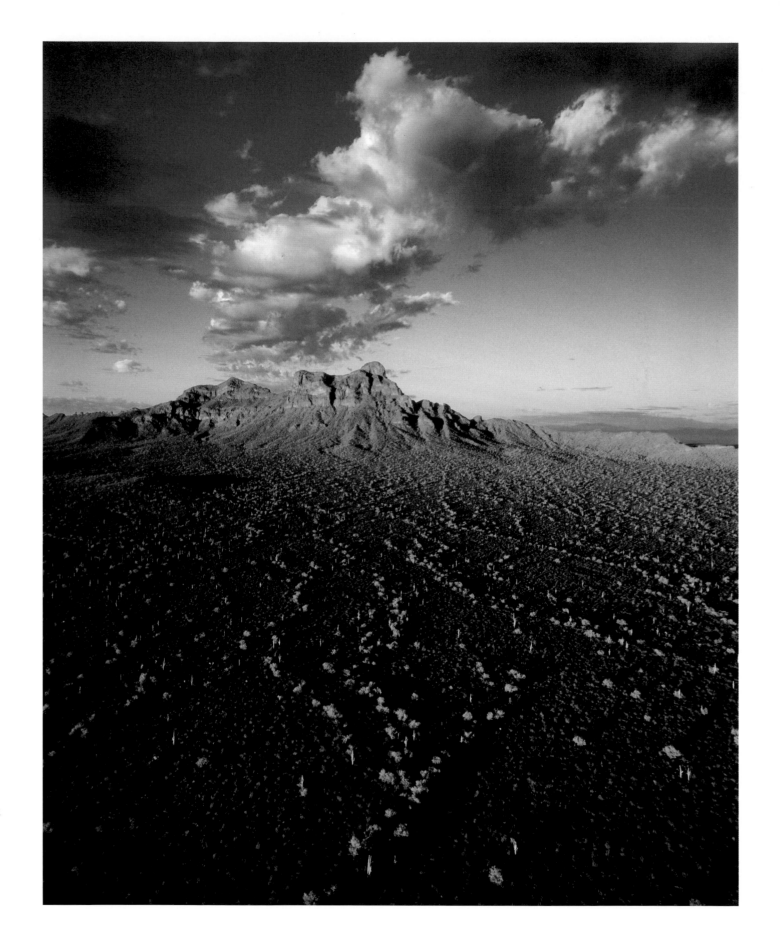

22

Southeastern slope of Picacho Peak State Park, Arizona

23

Summit crater in Pinacate Volcanic Field, Sonora

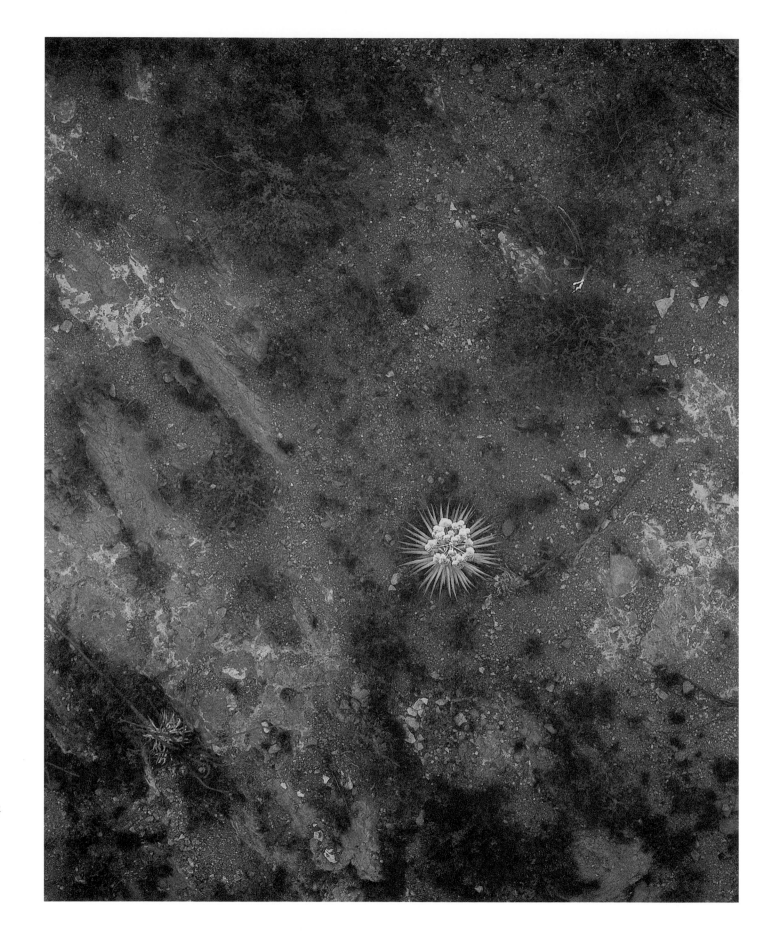

Flowering agave in Buehman Canyon, Arizona

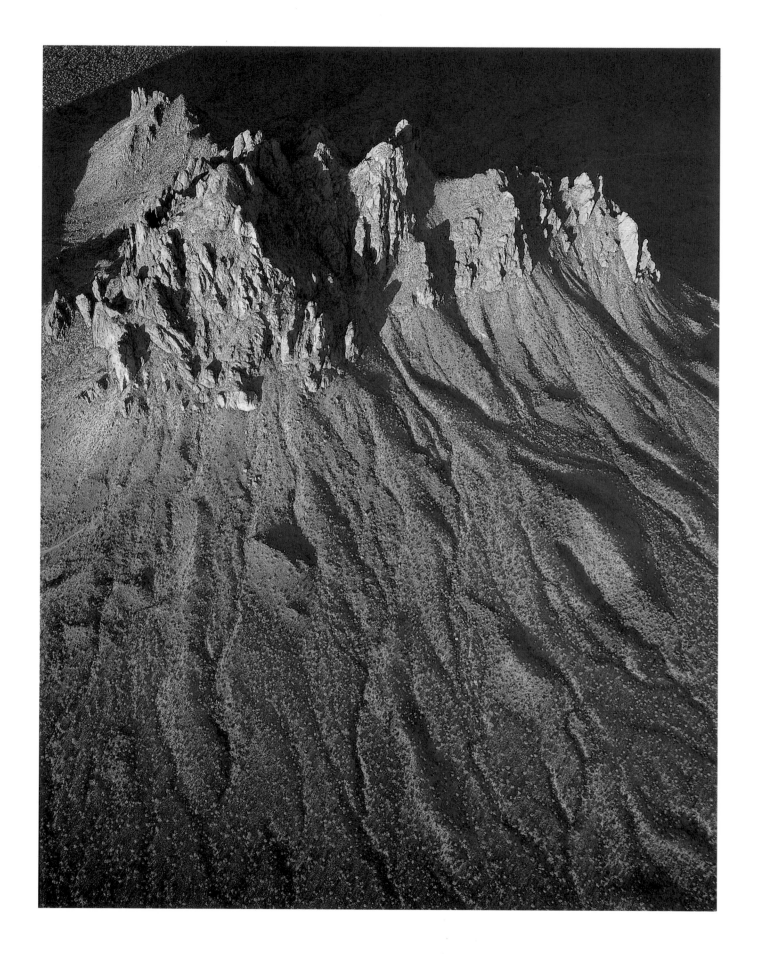

Ragged Top in the Silverbell Mountains, Arizona

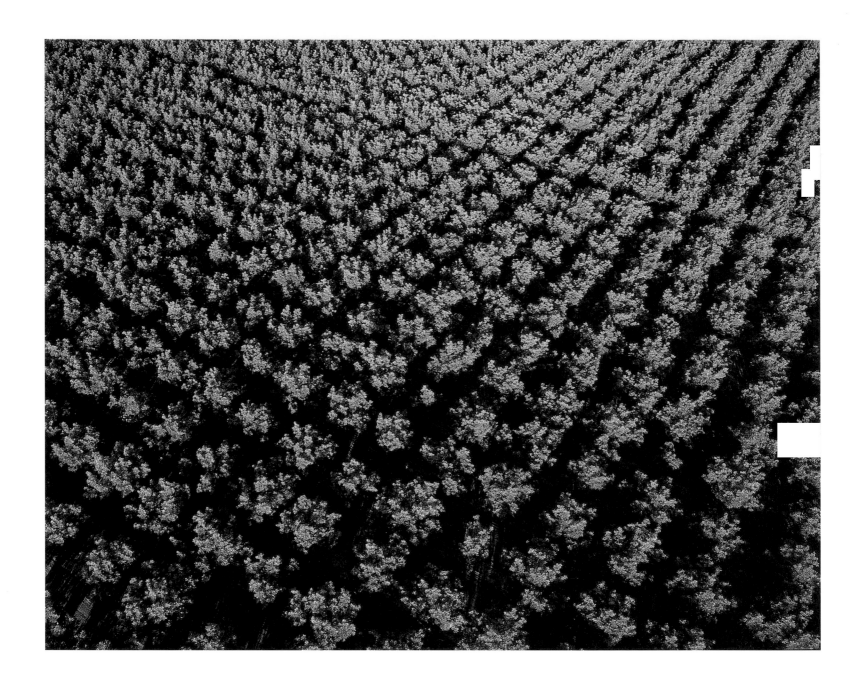

Pecan orchard, Bowie, Arizona

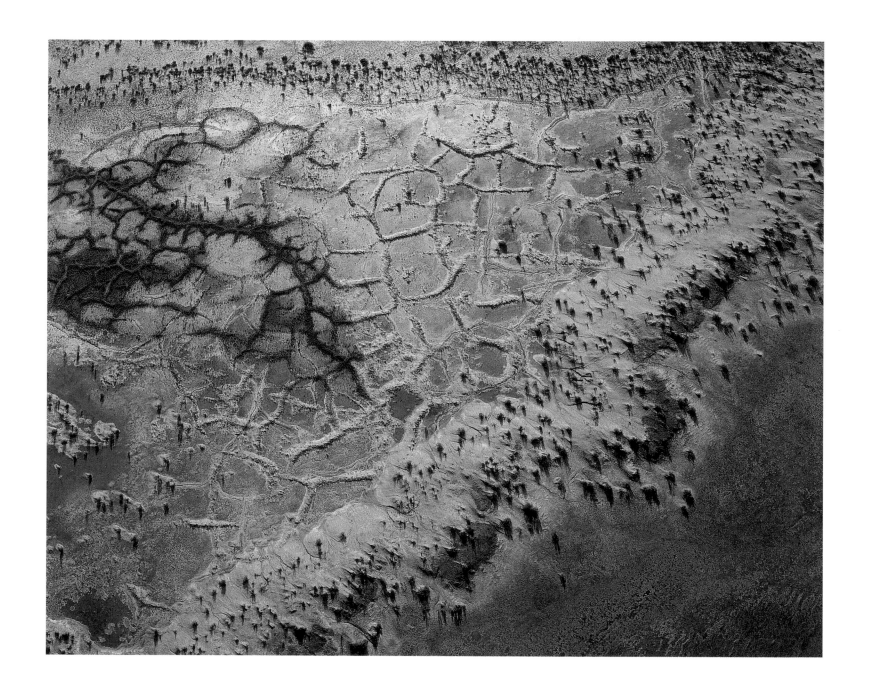

Willcox Playa in Cochise County, Arizona

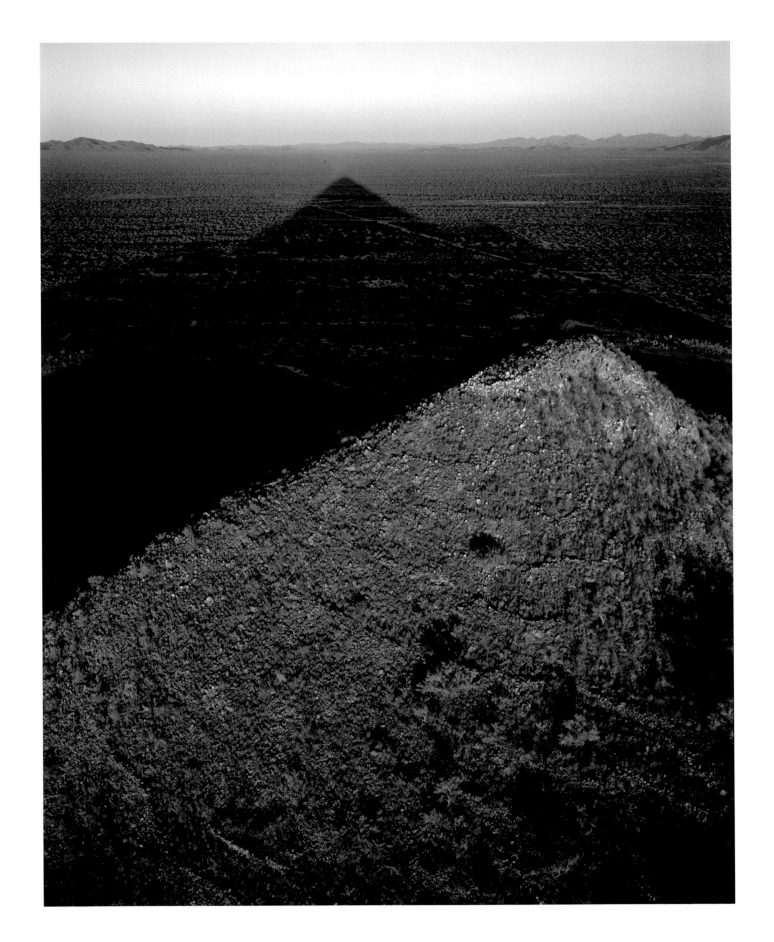

Prehistoric terraces on Cerro de Trincheras, Sonora

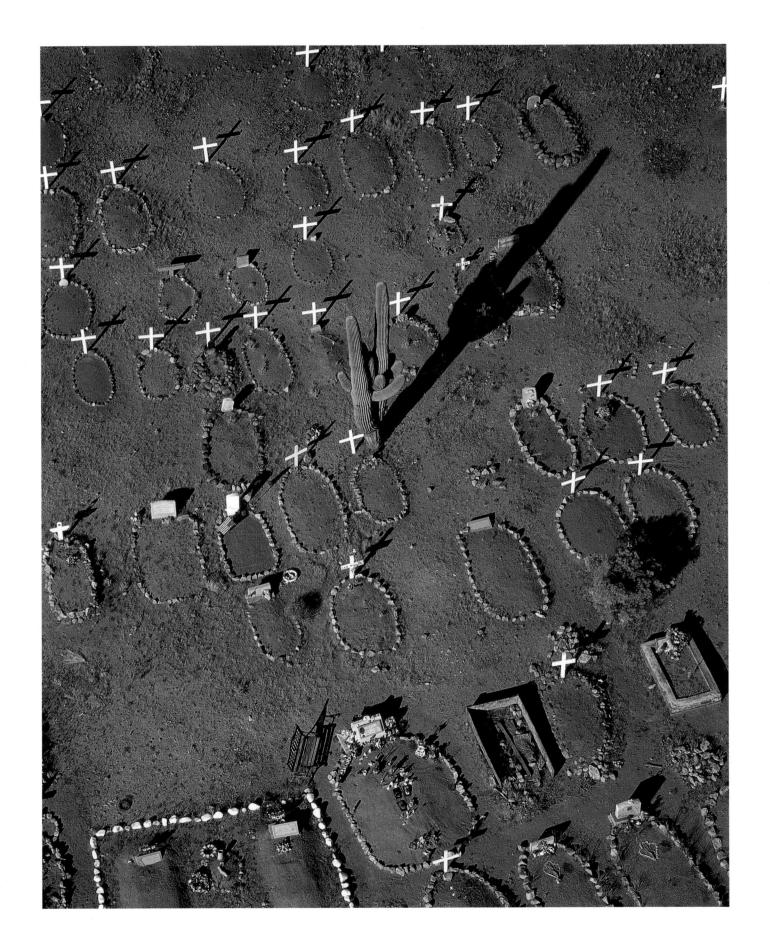

29

Cemetery on Fort McDowell Indian Reservation, Arizona

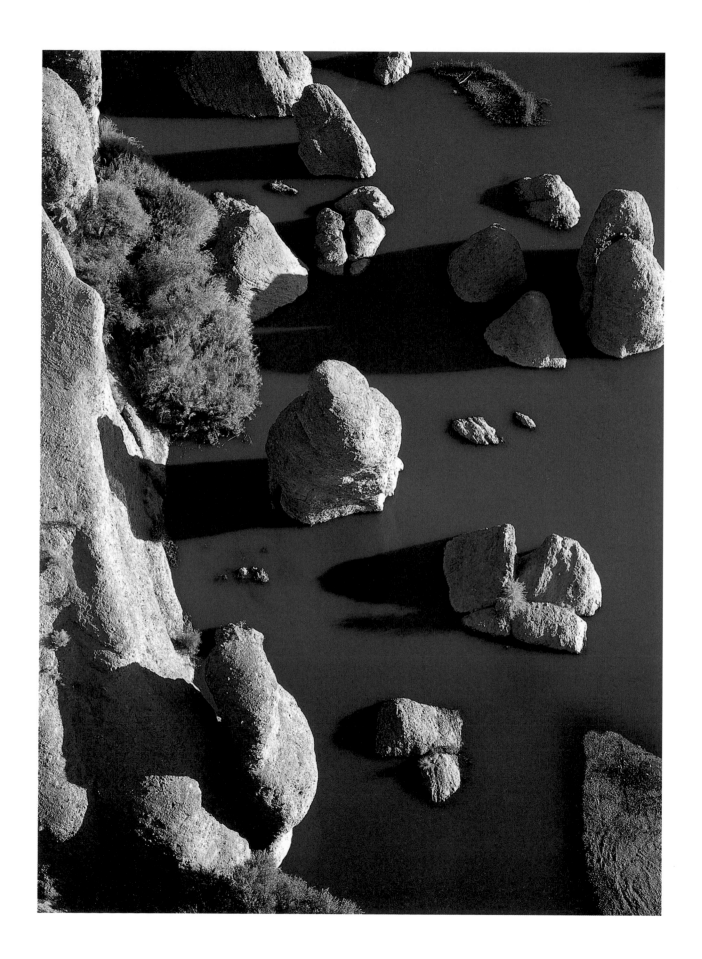

Needle Rock along the Verde River, Arizona

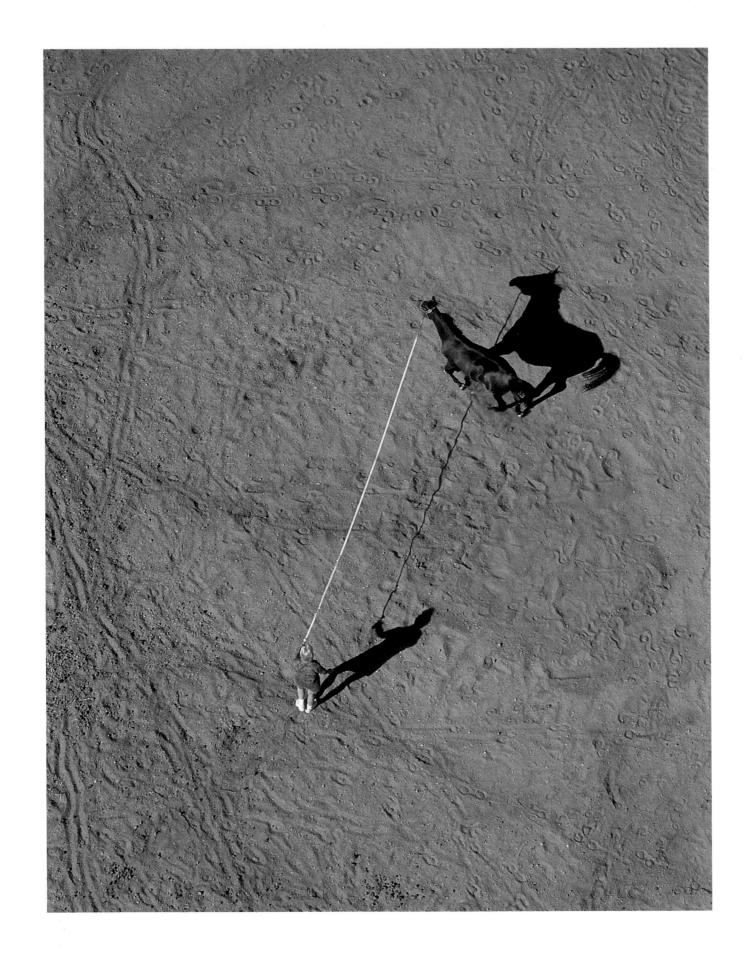

Horse and trainer, Colorado River Indian Reservation, Arizona

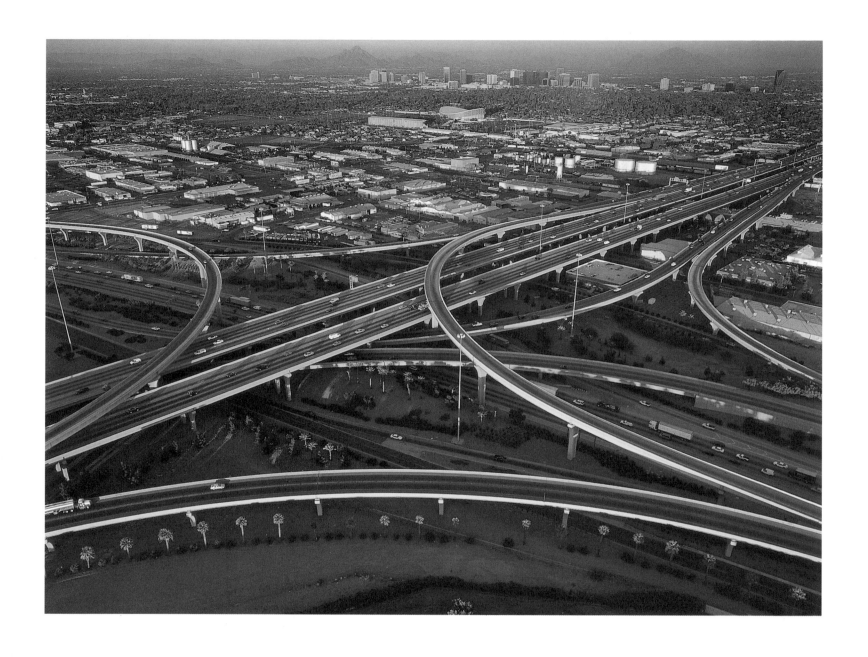

I-10 and I-17 interchange, Phoenix, Arizona

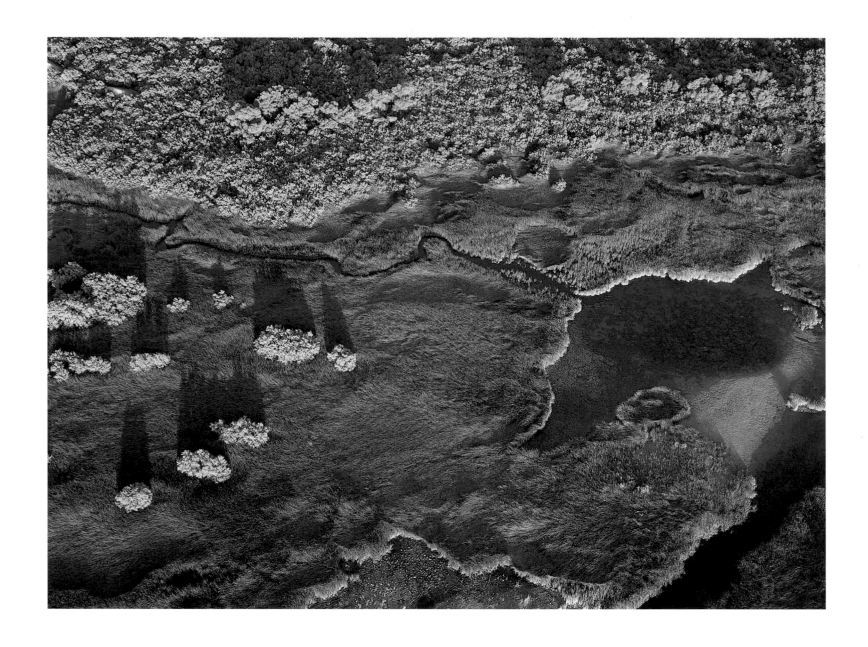

Mojave Canyon on the Colorado River, Havasu National Wildlife Refuge, Arizona

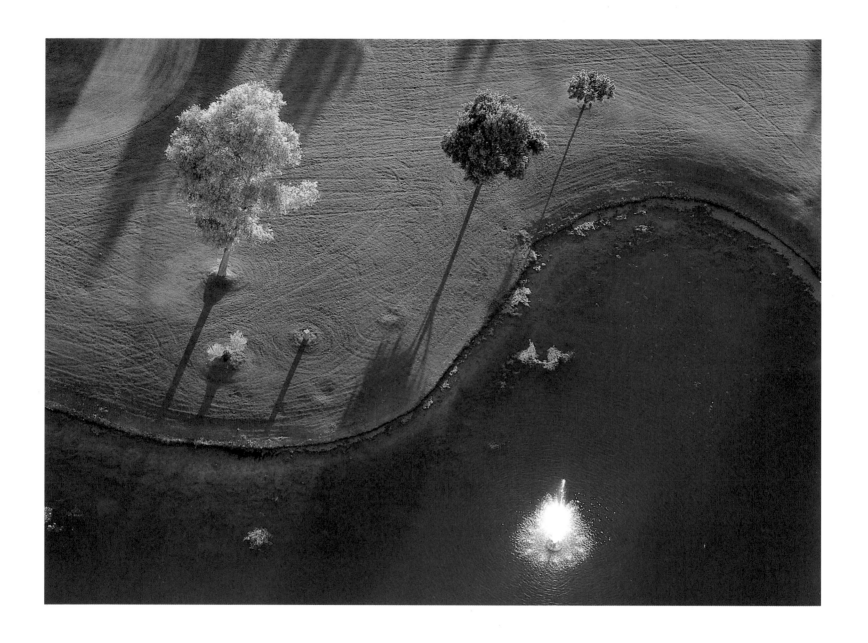

Omni Tucson National Golf Resort, Arizona

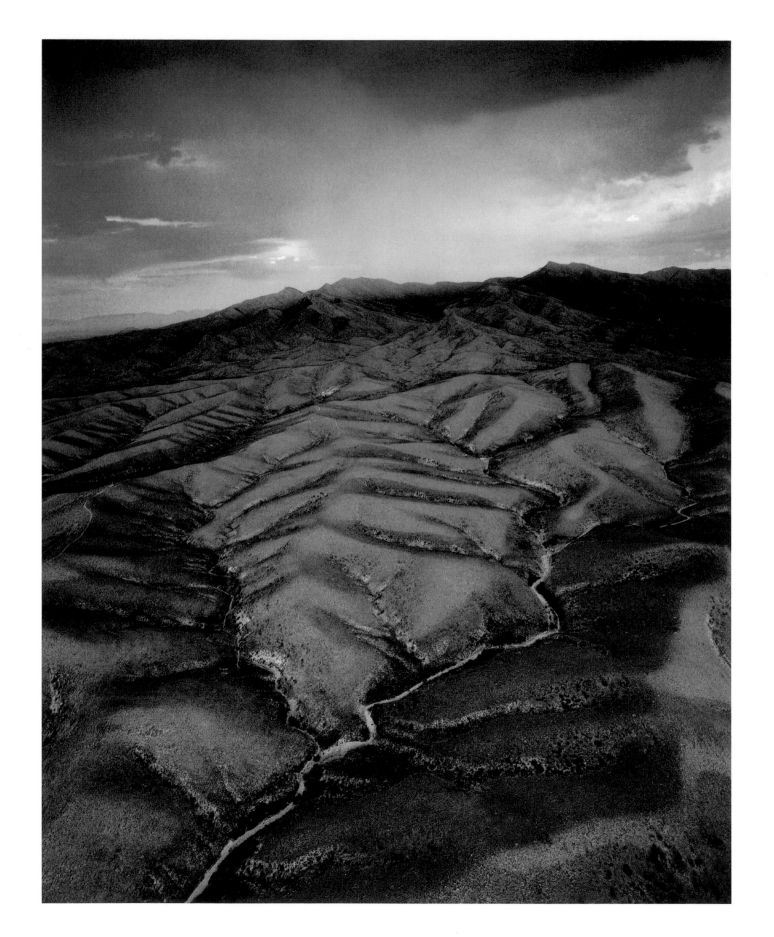

36

Monsoon shower over the Whetstone Mountains, Arizona

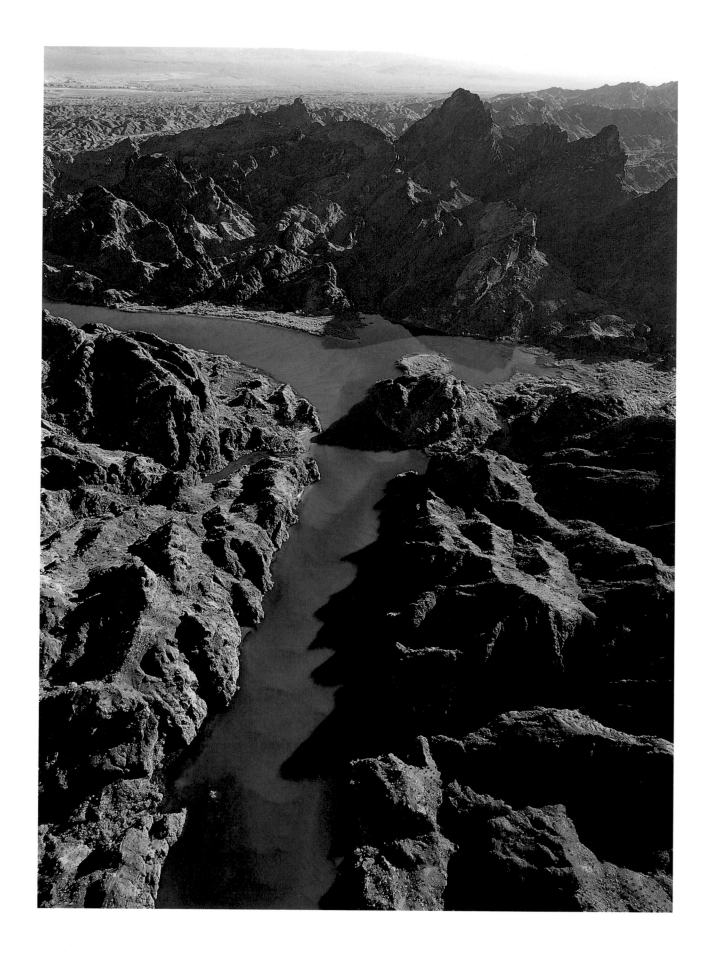

37

Topock Gorge and The Needles on the Colorado River, California-Arizona

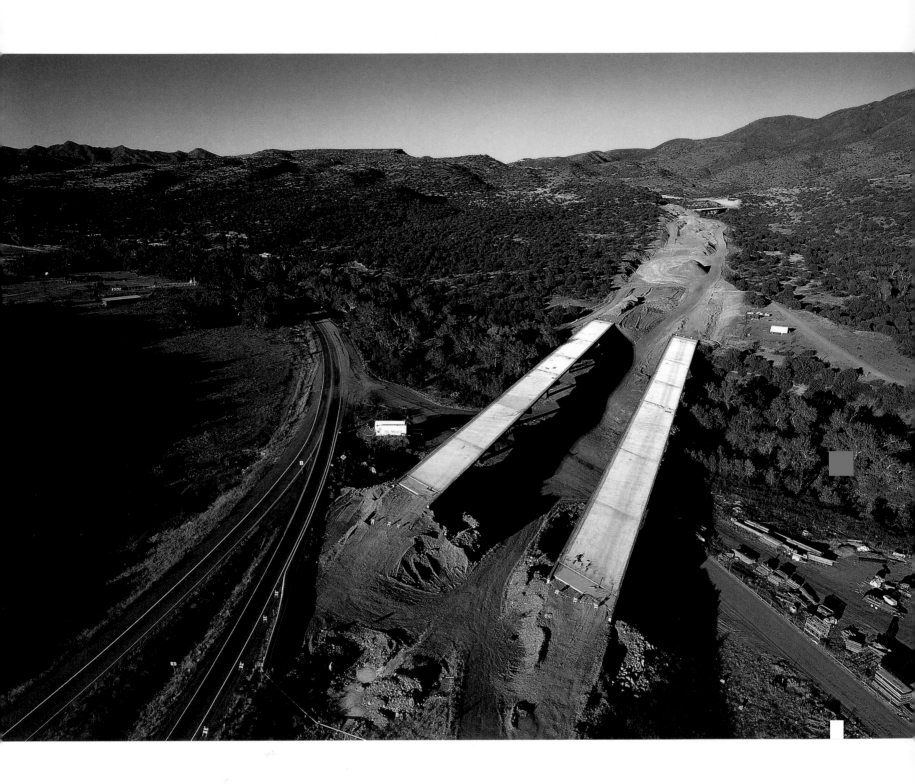

SUNFLOWER

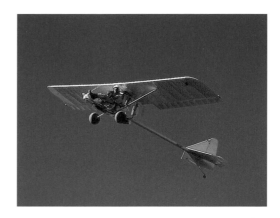

Airports are a luxury in my work. When I use them, I feel like a bicyclist on an empty interstate highway, since runways are designed for aircraft far more needy of space than mine. Often, I find myself conjuring up a takeoff out of some place that has no aeronautical function. This happens for two reasons. One, my plane can do it—three hundred feet is all it takes to get airborne. Two, I can't fly too far because my plane is slow. Thirty miles is my usual radius for photography, and many wild desert places are farther than this from a bona fide airstrip.

I'm always on the lookout for possible makeshift runways: playas, dry streambeds, old dumps, construction sites, horserace tracks, even dirt roads. Finding one of these near a landscape I want to photograph is a bonanza, but getting off the ground is often a story in itself.

I'm cresting a ridge outside of Sunflower, Arizona, with my airplane in tow. Here in the Mazatzal Mountains northeast of Phoenix, my eyes despair of sorting out the crumpled terrain. But the highway scribes a smooth line that I can't help but follow down into the valley ahead.

Right at the bottom, just beyond the point where the divided highway pinches down to two lanes and veers off into the glade of sycamores and cottonwoods along the creek, two

bridges stand beside each other like an immense equal sign on the land, glowing white with freshly cured concrete. They're blocked to traffic. I grasp the equation instantly with one look at the far side of the creek. The hills are gouged. Steep slopes gape open. A new road is going in—one that will not·turn and follow the creek, but instead will rise and cut through the foothills of Mount Ord in a few graceful arcs.

I park under one of the bridges and walk the construction track across the creek and up onto the new roadbed. The nearest airport is too far away, and I want to photograph these mountains. Can I get off the ground here?

The hard-packed dirt is littered with rocks, and I see the tread marks of monstrous tires here and there. Wooden stakes with neon pink ribbons flapping in the breeze mark the edges of the work area; beyond them is a loose forest of juniper and pinyon trees. Up a couple of hundred yards and off to one side, a small mountain of apple-sized rocks looms thirty feet high. It stands in a clearing as wide as the whole roadcut, and the track bends slightly around it before disappearing over the rise half a mile away. The gentle slopes and curves of a high-speed roadway are already carved out here, and the lumbering construction traffic seems to be making good use of them.

I break into a long stride past the rock pile and up the hill. If I take off in this direction, I need to know what's on the other side. At the top, I'm relieved to see the roadbed continue wide and leisurely down to another set of new bridges—any part of it a manageable landing zone if the engine were to quit right after takeoff. I turn around and survey the stretch I've just covered. This will work. There's only one thing left on my checklist: permission.

The white Suburban eases into the shadow of the bridge behind my trailer. Its door is painted with the same name I saw on one of the barricades blocking off the bridge up above. Even from a hundred feet away, I can see that the driver is checking out my rig, then me, then my rig again. As I close the distance, I take off my hat and then my sunglasses. The driver's window glides down.

"Can I help you?"

"I hope so." I'm glad we're in the shade so I can relax my squint for what I'm about to explain.

Ken Gustafson is gone for a quarter of an hour. He has my business card and his own version of my admittedly strange request. He's the manager of this project, so he doesn't need to get someone else's go-ahead; all he said was he'd be right back. Meanwhile I look at my map. This is a long way from anywhere. When he returns, he invites me to get in the Suburban.

"How wide did you say the wings are?"

"Thirty feet."

"And how high?"

"Four feet."

"What do you think about using the bridge?" He nods toward the south half of the equal sign as we pull up out of the streambed. "It's six hundred feet long, thirty-five wide, with three-and-a-half-foot railings. No one drives on it."

He's into this.

"Hmmm," I say. "You know, that's a little tight. If the wind comes up, I wouldn't have a lot of leeway. I was thinking of the construction road just beyond the bridge—between there and the rock pile. That'd be plenty of room."

I explain once more how I won't be a traffic conflict. How for takeoff, he can watch from the top of the hill to make sure none of his crew comes over without warning, and how for landing, I can scope out the whole scene from above and wait until all is clear before coming in.

"You'd be all right with that rock pile?"

"I'll be up and over it if everything goes okay, and if not, I can steer around it—there's enough space."

"All right then. Let me show you a little of what we're doing here so you'll know what you're looking at when you get up there—you got a minute?"

I look at the shadow of the truck, how far out it lies. The light hasn't begun to yellow yet.

"Sure."

His Nordic frame makes the cabin of the truck seem cramped as he leans over the steering wheel and squashes the accelerator. I fasten my seatbelt, and not just out of habit.

Minutes later we're nosing up to the end of the bridge at the bottom of the next valley. A wall of concrete half fills the windshield—it's the roadbed of the finished bridge as it stands waiting for the highway to be built up to join it. The Suburban lurches softly as Ken shifts into PARK.

"We've got a riparian crossing here." He says this solemnly, as if I should instantly recognize the weight of his words. He senses that I don't. "We're not allowed to cross this stream during construction. State law."

"How did you get the bridge in then?"

He's got a sly smile on. I've been set up. This is his pièce de résistance.

"Crane. We dropped a steel truss in here on the pillars we put up, one on either side of the creek. Then we built the bridge off the truss. First one, then the other. This is a seven hundred-foot-long span, and we've got two bridges, each completely separate from the other. They slope upward across the span. And curve too."

I'm sitting up tall in my seat, tracing the railings in front of me out through space, watching them converge like railroad tracks to a point on the far end. Then I see he's got his fingers up, marking off empty air.

"We built 'em an inch apart, the whole way."

I look back at the bridge. No wonder I thought it was all one piece. There's the gap. It looks like nothing.

"And we never touched that stream."

Back at my plane, behind the rock pile, I'm unfolding the wings. I'd like to be airborne in twenty minutes, but Ken's not finished. I prefer not to be talked to when I'm getting ready to fly. It looks simple, but every little thing I do is laden with the weight of life and death—mine. Of necessity, I've learned how to hold my thread of concentration on the plane while listening, but sometimes I have to ask for silence.

"The thing about this project is it's the last of its kind."

Other times I stop what I'm doing so I can listen.

"What do you mean?"

"Four lane, divided—practically an Interstate. We just don't get these anymore. Everything these days is expansion or improvement of existing roadways. How often do you see a new alignment through virgin terrain?"

I flash back over my years crisscrossing the country, studying the endless net of highways from the cockpit of whatever plane I happened to be flying. It's quiet while the words sink in.

"How long is your stretch? What's going to happen to the old road?" I begin to feel a new surge of interest in flying around here. I want to see how all this is laid out, something that the mountains make impossible at ground level.

"Most times they close 'em down and dig 'em up, but the folks around here put up a fuss. They want this one kept open—too many ranches and off-road trails around, you know. So the state and the Forest Service made an exception."

He turns to look up the roadbed, sunk well below the surrounding chaparral. It feels like a canal, ominous in its emptiness.

"Our section is the last one. After we're done, the whole Beeline Highway from Payson to Mesa will be four lanes. It's seven miles, the roughest stretch on the whole route. That's why it's last. You know where Slate Hill is, coming up along Mount

Ord on the other side?" He gestures into the northeastern sky. "You'll see it when you get up. Our project forks off there where the road narrows down to two lanes, and then ends up right here at these bridges. Seven miles, three bridges. We sure know how to pick 'em."

The hum of rolling rubber rises through the old sycamores half a mile away. In less than a year, that same sound will be coming from where we're standing.

The tail wheel is sitting less than a yard away from the end of the bridge. I'm strapped in my seat, ready to go. It's a good six hundred feet to the rock pile: plenty of room for takeoff. I wave to Ken and bring the throttle up. The wind blast from the propeller is aimed squarely at the tail, giving it lots of air right away. I feel the tail wheel lift free; that end of the plane is already flying, and I've only rolled a few yards.

Coming up through twenty-five to thirty miles an hour I'm picking my way among a few dry puddle holes and trying to avoid the biggest rocks in the work road. The rudder has enough air flowing over it to allow me to steer the plane even though the tail wheel isn't on the ground anymore. As speed magnifies the subtle contours of the packed dirt surface, the plane bounces lightly. I'm working the control stick as if there might be life on the other end. I can feel buoyancy in the wings, but they're not quite ready. The tires settle and kiss the track once more. Then, in an instant, the ground is irrelevant.

My mental space has become rarefied. No rational progression of thoughts, no recognizable ideas. I'm mainlining the moment, a rapt student of all that's streaming into my senses. Anything can happen right now, and I must be ready. Each second passes like a bucket on a water wheel. Filling…full…dumping. Next! If the engine quits now, where will I go? If *now*, where will I go? If NOW , where? Each bucket holds different water, each question a different answer.

I've prepared for this. Somewhere inside are all the bits of information I've gathered ahead of time, and I am stout in my self-trust. If I'm paying full attention, and something goes wrong, I will know what to do. I've scouted my options. I have

good judgment. I know my airplane. I am skillful. This is my antidote to the animal fear that rises up in my body during every takeoff.

The rock pile is twenty feet below my left wingtip as I swoosh past. I see Ken looking up at me from his hilltop station, arms akimbo. His long shadow makes him look even taller than he is. Out beyond him, the bare earth roadbed splays down the far side of the hill to the riparian crossing.

I am high enough now that I can begin to think again. There are more places to land, and my altitude will give me time to choose the best one if need be. I draw a deep breath out of the airstream gushing over my face, then let it go. I'm back in the sky.

Only one road passes through these mountains, and I'm over it. North and south of me is nothing but unbroken wild country, spanning a full degree of latitude. Circling higher to get my bearings, I can see the serried spine of the Mazatzal Mountains cleaving the sky in both directions.

I don't mind flying around aimlessly for a while because I need some time to make sense of all that I see. Eons of oozing lava, slipping plates, and intense weathering have scrambled the face of this land into chaos. Boulder Mountain stands in the south, darkening near the top with its rim of basalt and patches of high-country conifers. Dikes slice across nearby hills with no respect for contour. Their jagged walls rise and fall in the scrub, often leading to rotten-looking mounds of exposed volcanic cinders.

There's Sycamore Creek meandering through its little basin before it squeezes out past Crabtree Butte and carves west out of the mountains toward the Verde River. From above, the channel bulges with the rust-tinged foliage of its namesake tree. That hodgepodge of ranch buildings and glinty new homes sprinkled around the valley is Sunflower—no store, no post office. Story has it that when white settlers first entered this little pocket in the mountains, it was carpeted with blooming sunflowers. The endless stream of vehicles on Highway 87 has no reason to slow down as it passes through here now—no reason

42

other than the road change. Cars race downhill like bright little beetles struggling to get around the slower trucks and RVs before the divided highway steps down to two lanes at the creek.

Mount Ord is less than three miles away, its pointy summit still half a mile above me. The new road disappears around its northwest shoulder, and I want to see where it goes. I fly closer to the mountain, wary of its bulk. Before long I can see the other end of Ken's project. The old road is laid in right along Slate Creek on the north side of Mount Ord, and where it starts climbing over the pass into the Sycamore Creek basin, the new road bed peels off like an impatient driver looking for a shortcut. It's not nearly ready for traffic yet, but there is no question about its purpose. My eyes can't pull away from this new swath slithering bare as skin through the deep sage-green chaparral.

From up here, the whole process is plain to read. Where the land goes down, the road stays up. Where the land rises, the road stays low. Ken's people cut out the hills and use them to fill in the valleys. They drive long nails into the hills to hold them back and throw bridges across streambeds they can't fill with dirt. The road seems to render its host terrain irrelevant. This is the charge given the builders—to make passage as easy and predictable as possible. It is the will of the people carved in the earth.

I am one of those people. I steer along the orange cones of progress like everyone else. I probably wouldn't be flying here in these mountains right now if it weren't for this road. I'm relaxed and reflective looking over Ken's handiwork because I know I could land anywhere on it without a scratch if I had to. In the air, my immunity from terrain is an illusion, and though I may appear aloof and free to someone on the ground, I'm actually tangled in the sinewy web of place.

For the first human entering a wild land, survival is all that counts. For the tenth, a sense of discovery may dawn. For the hundredth comes awareness of resources. By the thousandth, a route is defined. When tens of thousands pass in a single day, as they do below me right now, civilization has secured a corri-

dor, and travelers may safely ignore their surroundings. Ever after, it's our choice whether or not the land matters to us; it will not command our respect again the way it did when it was wild and we were few.

I gird up my loins, mustering the courage of pure curiosity, and venture off into the hinterland, miles away from the road. I find places to photograph that turn strange and wondrous in the raking afternoon light. I linger to watch the sun dim in the great exhalations of Phoenix. The disk probes for the actual horizon as it sinks into the murk, but dies without finding it. Then I turn toward the distant gap in the mountains where Sunflower and my little runway lie waiting.

My eyes grow wide as a madman's to soak in the last remaining light. I set up the landing approach easily, needing no headlights to find my way. I even time my descent for a lull in the traffic on the highway so no one will come barreling over to rescue me after I plummet from the sky.

The engine is already off as I roll past the rock pile to my trailer. I'm taking off my helmet and gloves when a pickup lunges up out of the creek bed and rumbles to a stop beside me. The driver is a young man. In the light from his instrument panel shining up under his hardhat, I can see his appealing dark eyebrows and closely trimmed mustache. He leans out over his elbow, and on the door below him I see the words "Arizona Department of Transportation."

"You know, I don't think this is such a good idea."

I'm impressed with his reserve, under the circumstances.

"Well, Ken Gust—"

"Gustafson? You talked with Gustafson about this?" He says the name like he'd sanded off its bumps a long time ago.

"Yeah, he said it would be fine."

"Well, if Gustafson OK'ed this, you're all right."

"Pretty amazing project you've got here," I offer. Fresh down from the sky, I'm still feeling expansive.

"You oughta come back when it's finished!"

He cracks a half-smile and pulls away into the dusk.

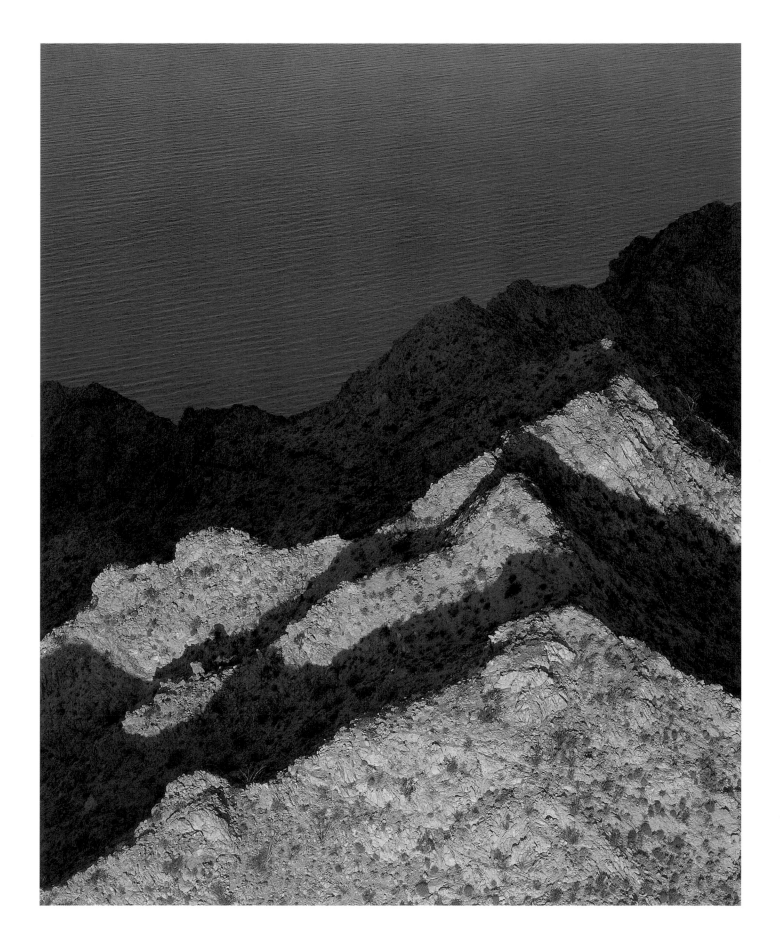

45

Sierra Julio and the Sea of Cortez, Sonora

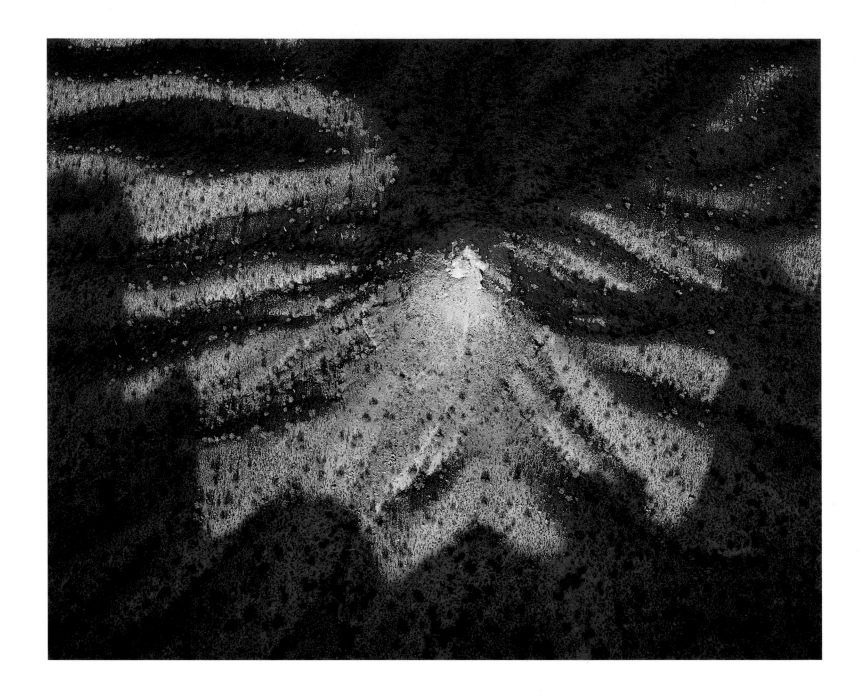

46

Yellow Peak in the Santan Mountains, Gila River Indian Reservation, Arizona

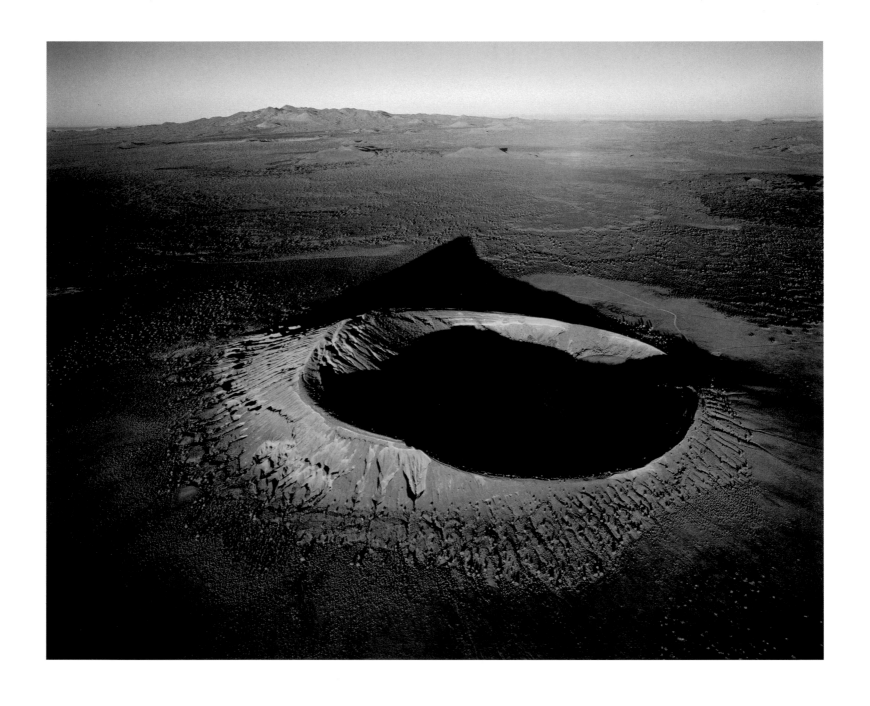

Cerro Colorado in Pinacate Biosphere Reserve, Sonora.

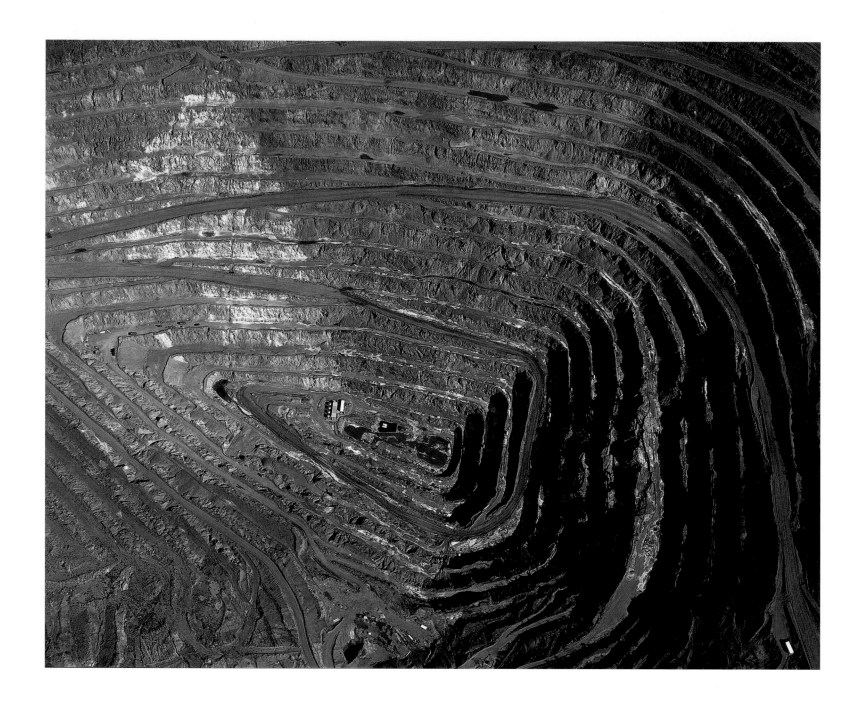

Tiger open pit copper mine, San Manuel, Arizona

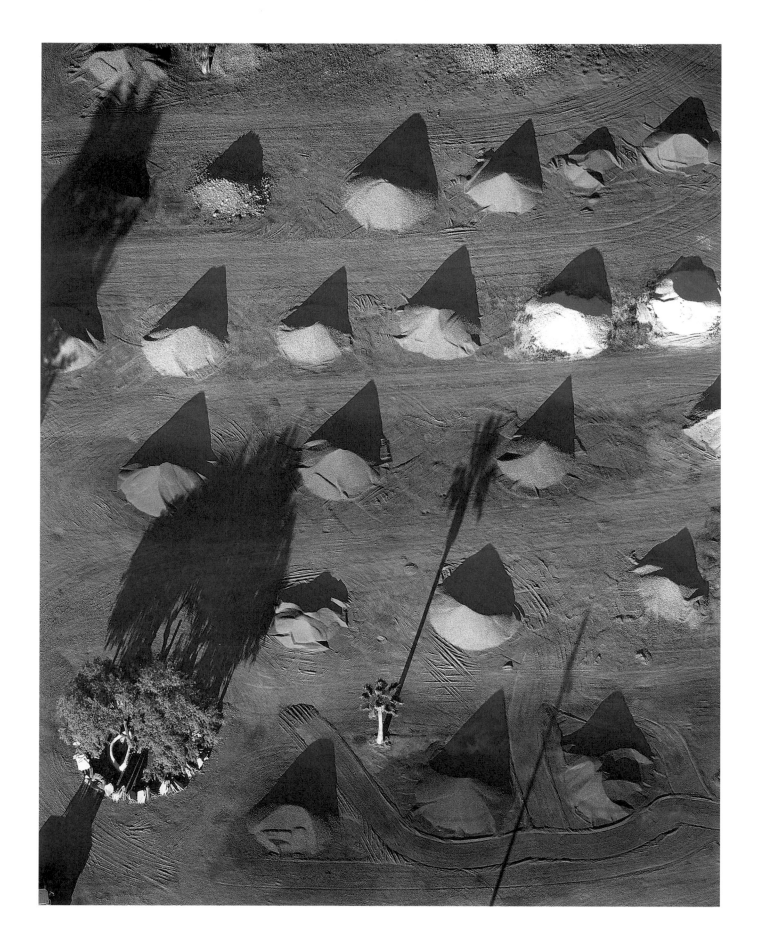

Decorative landscaping rock, Tucson, Arizona

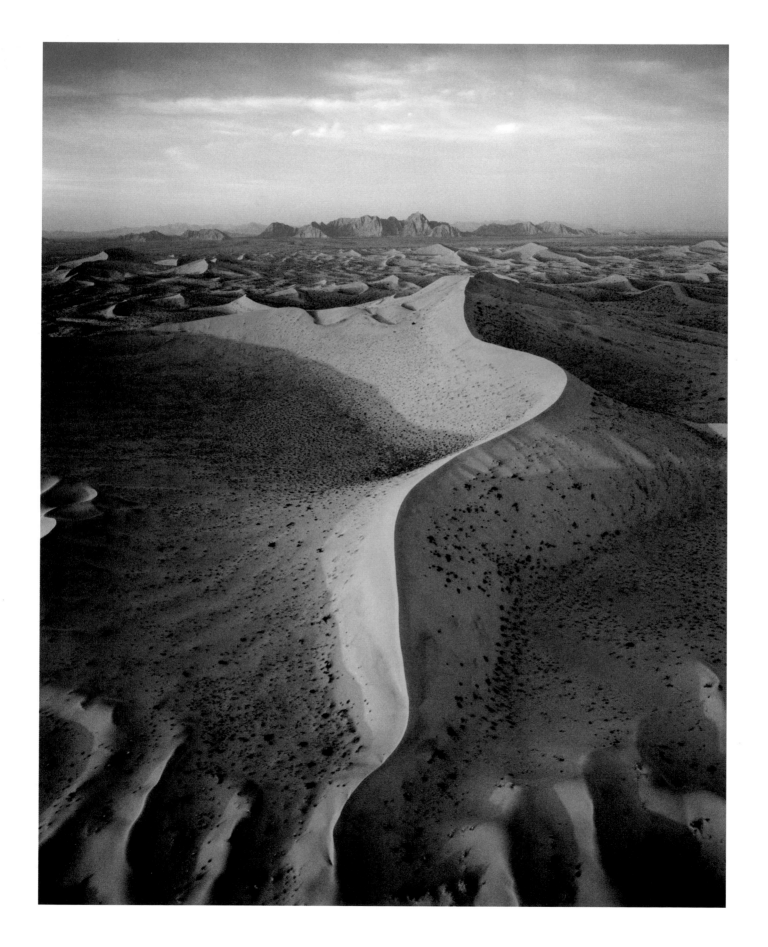

Dune crest in Gran Desierto, Sonora

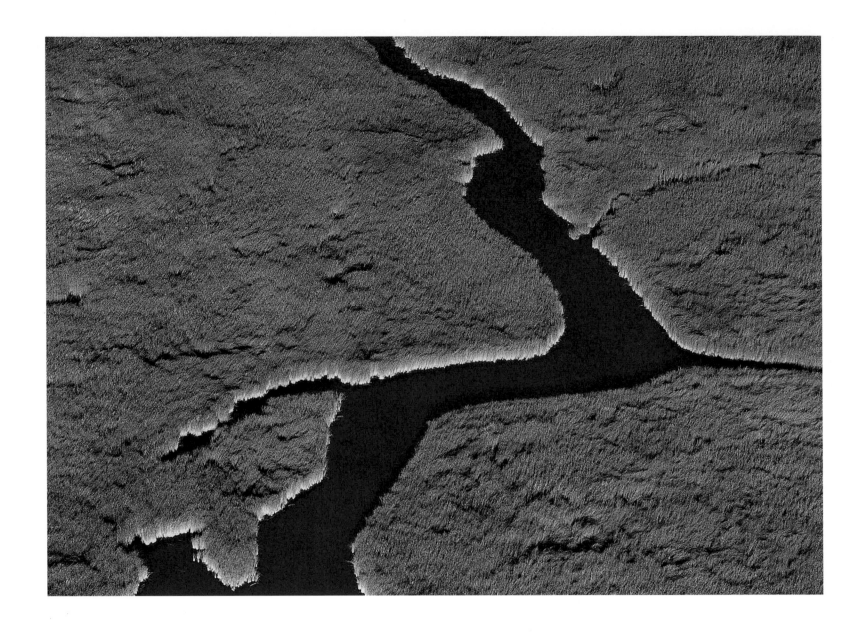

Topock Marsh along the Colorado River, Havasu National Wildlife Refuge, Arizona

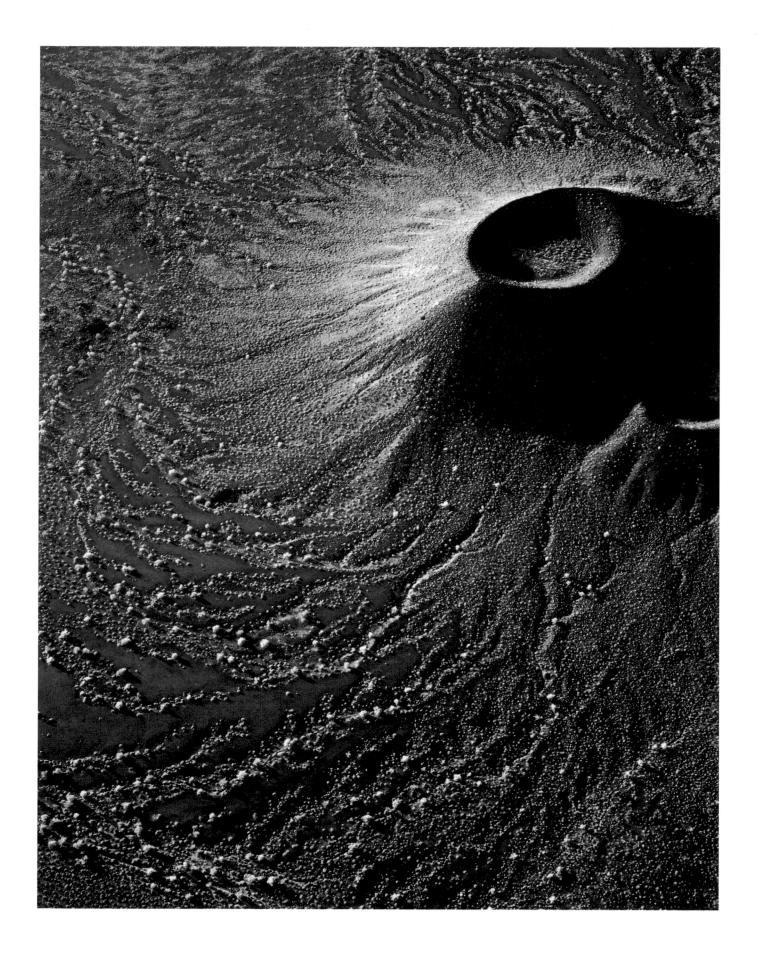

I'itoi's Castle in Pinacate Volcanic Field, Sonora

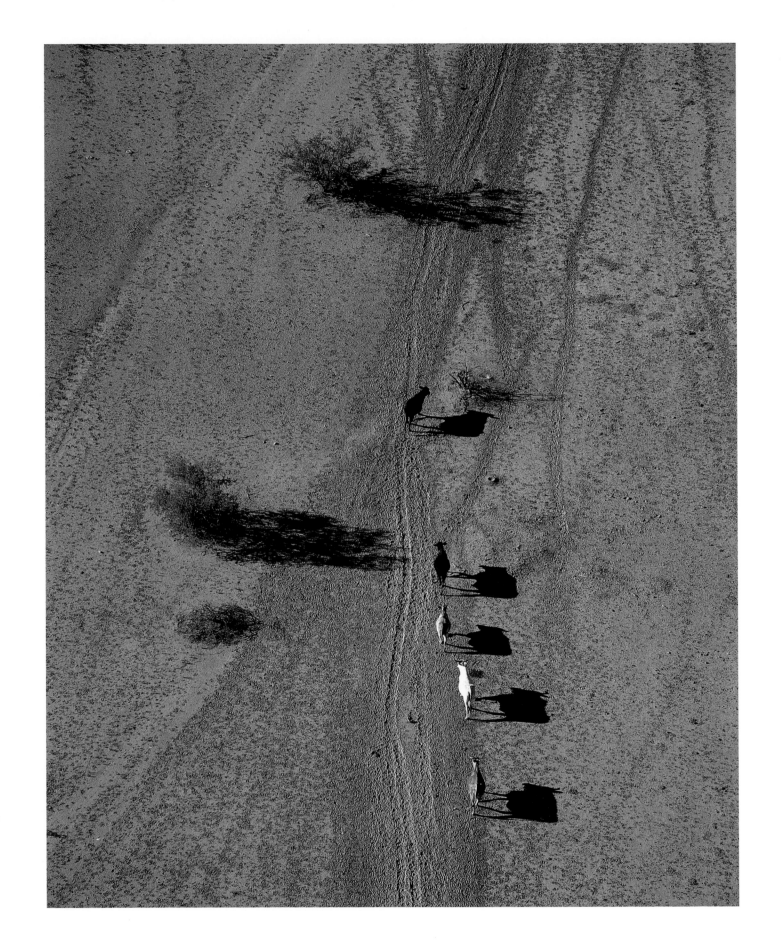

Cattle en-route to water, Rio Magdalena, Sonora

Lake Havasu on the Colorado River, California—Arizona

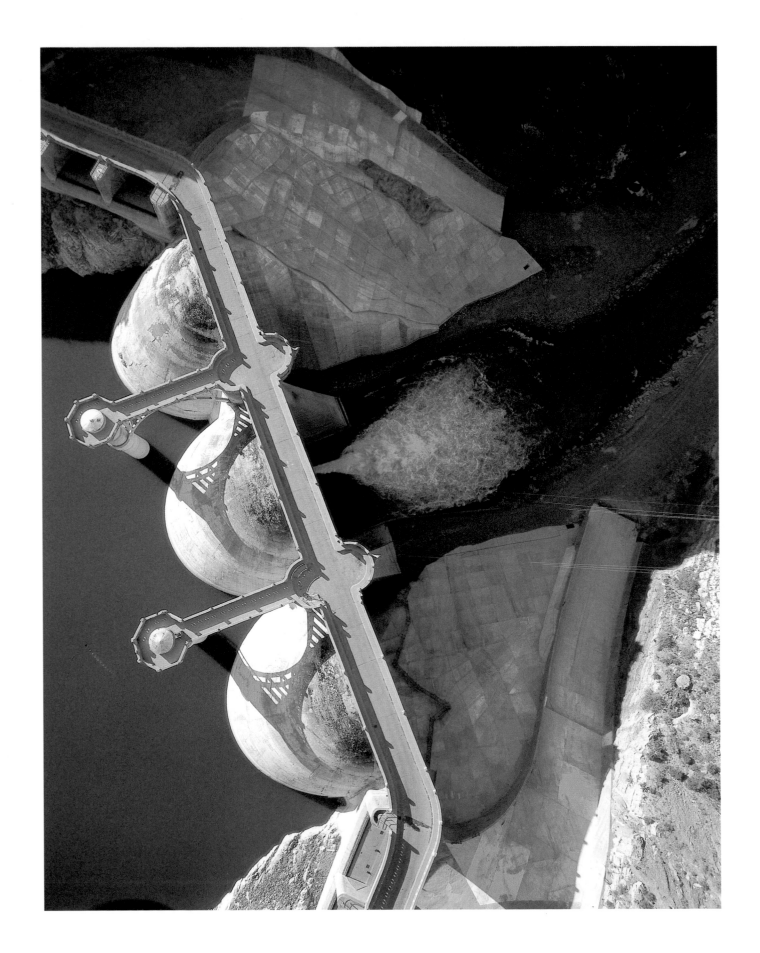

Coolidge Dam, San Carlos Reservoir on the Gila River, Arizona

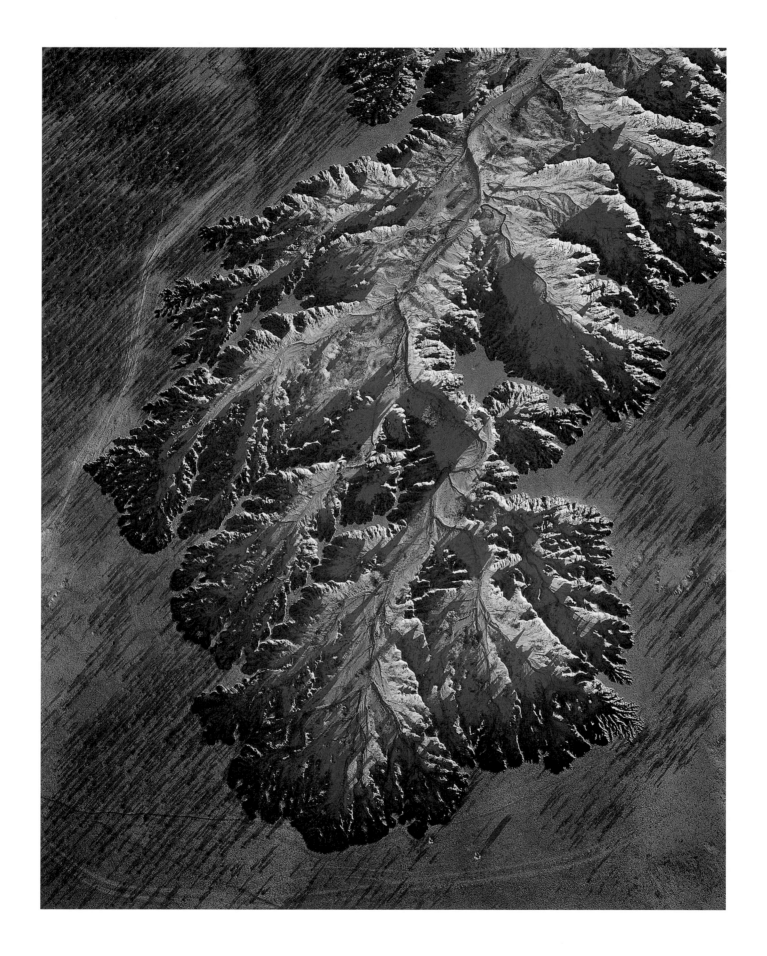

Headward erosion along Rio Boquillas, La Playa, Sonora

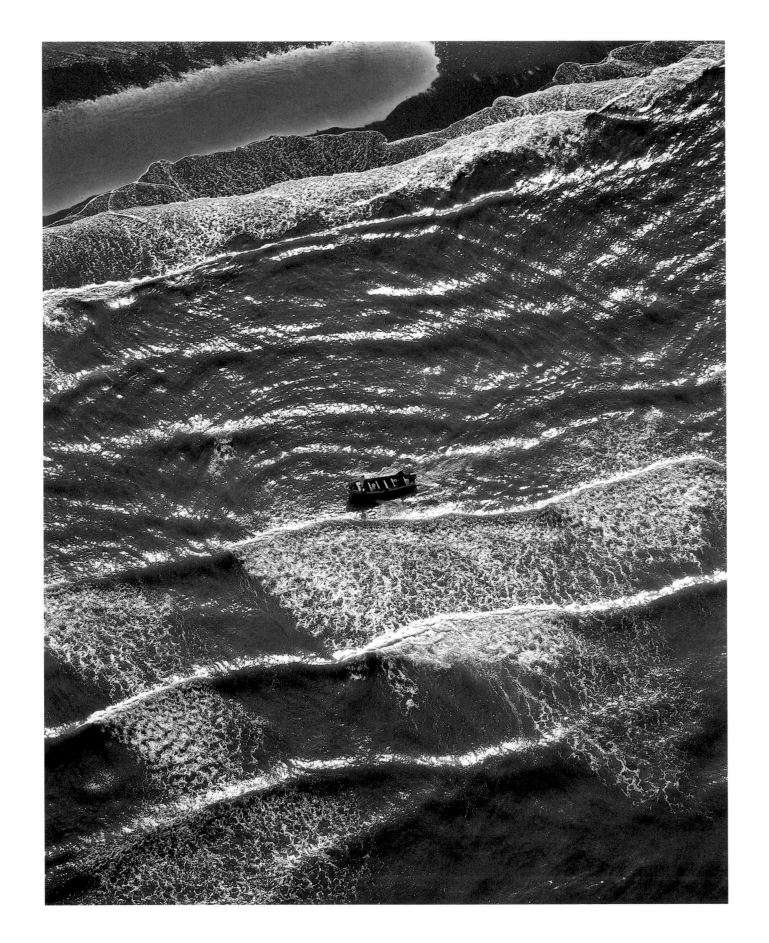

Fishing boat, Desemboque, Sonora

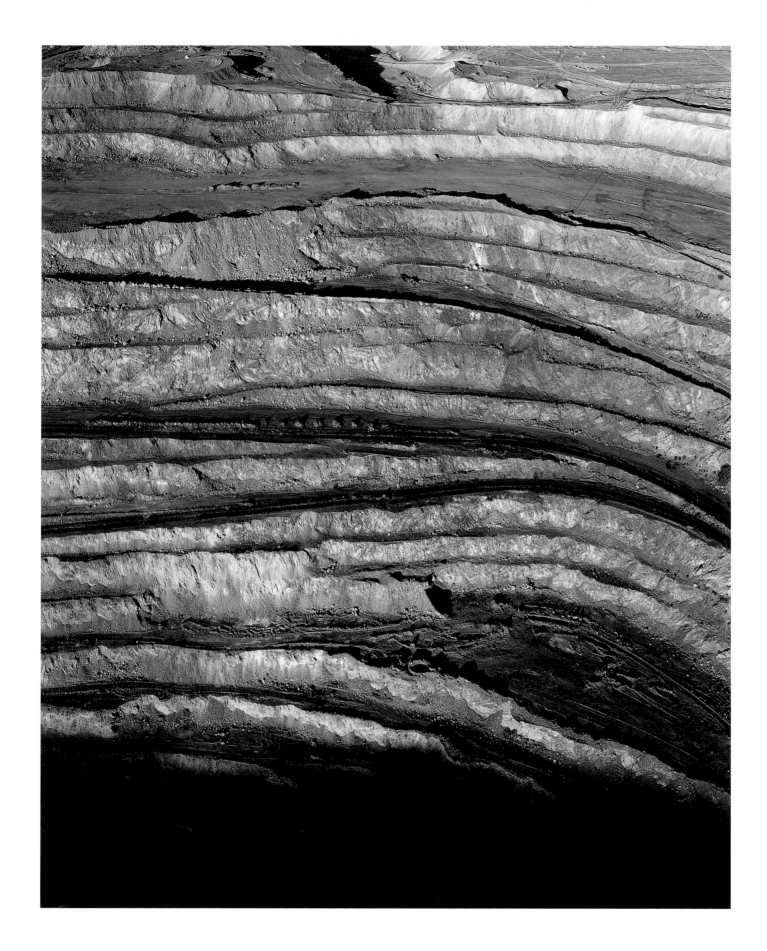

New Cornelia open pit copper mine, Ajo, Arizona

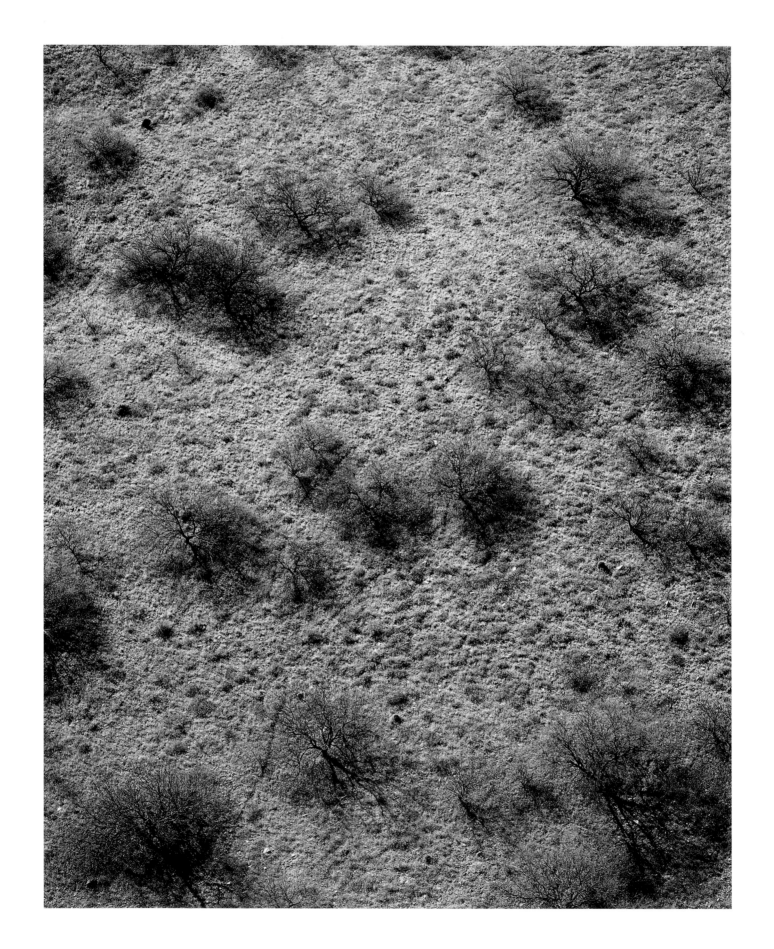

Mesquite trees and wildflowers in the Atascosa Mountains, Arizona

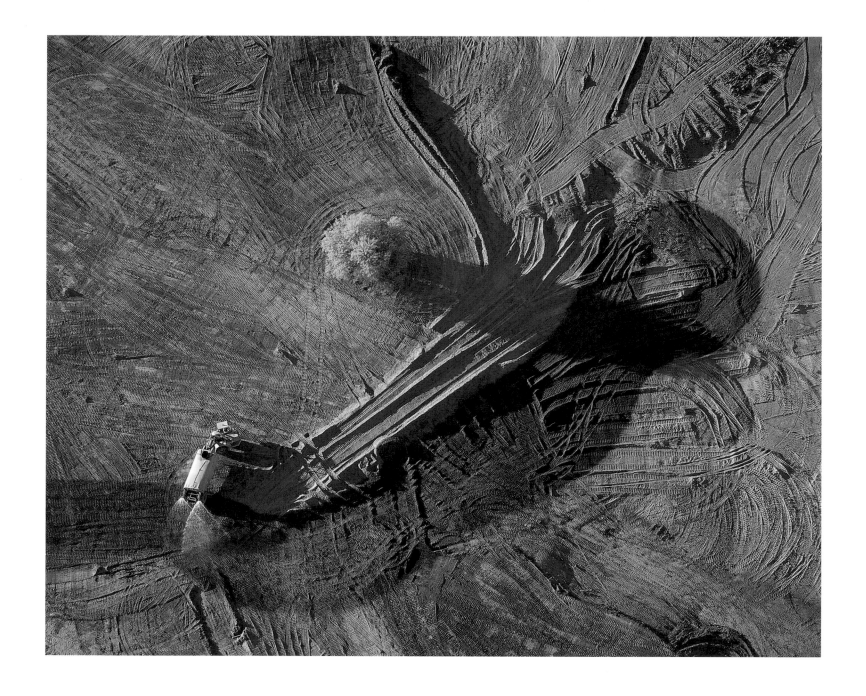

Blooming palo verde tree and new golf course development, Tucson, Arizona

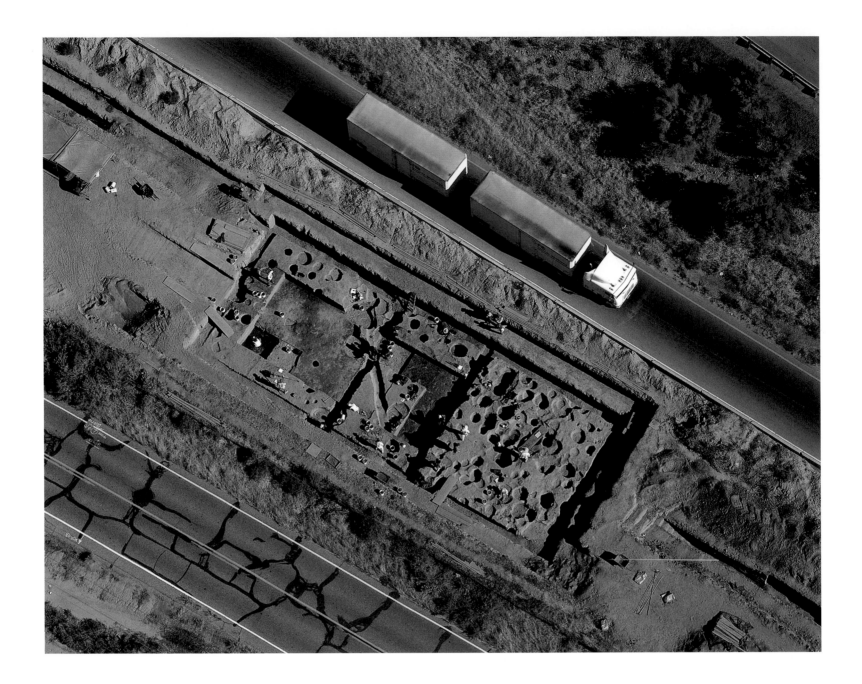

Archaeological excavation preceding I-10 road widening, Tucson, Arizona

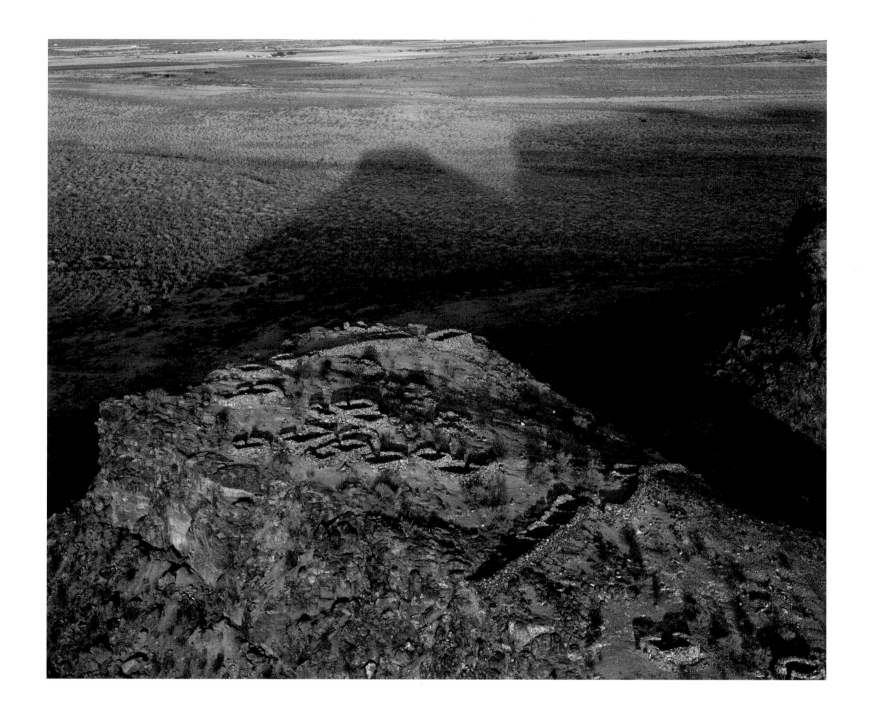

Prehistoric Hohokam village site overlooking the Gila River, Gila Bend Indian Reservation, Arizona

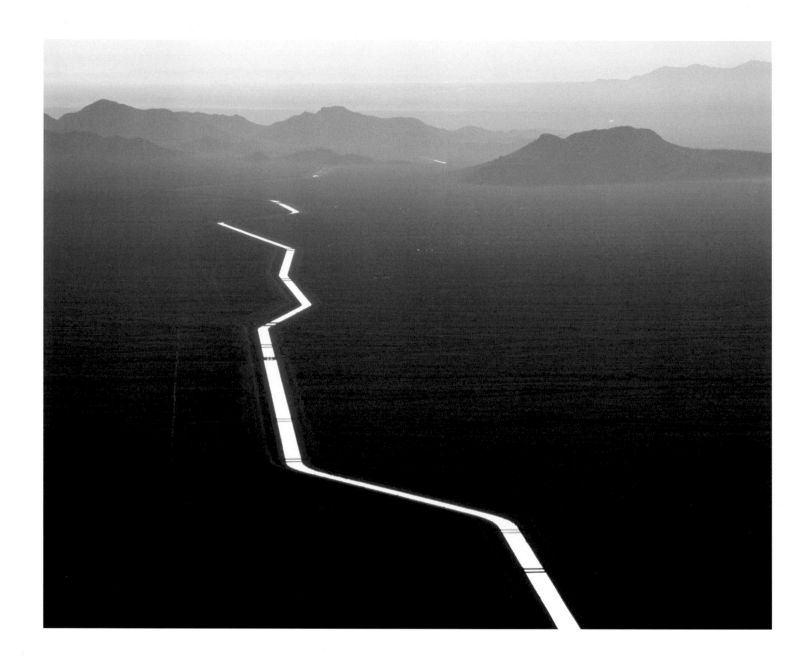

Central Arizona Project aqueduct, Tonopah Desert, Arizona

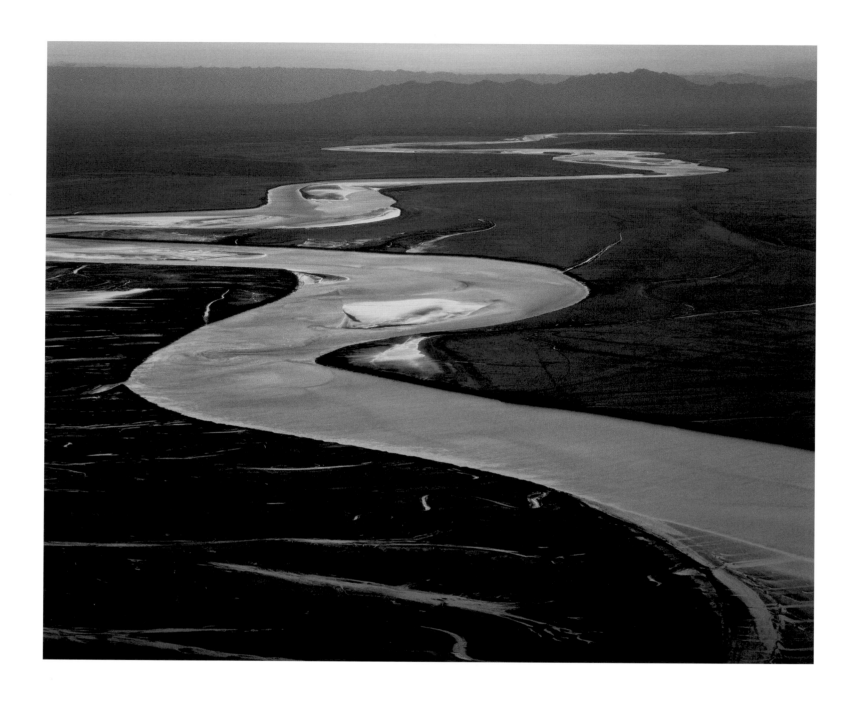

Tidewater in the Colorado River delta, Sonora

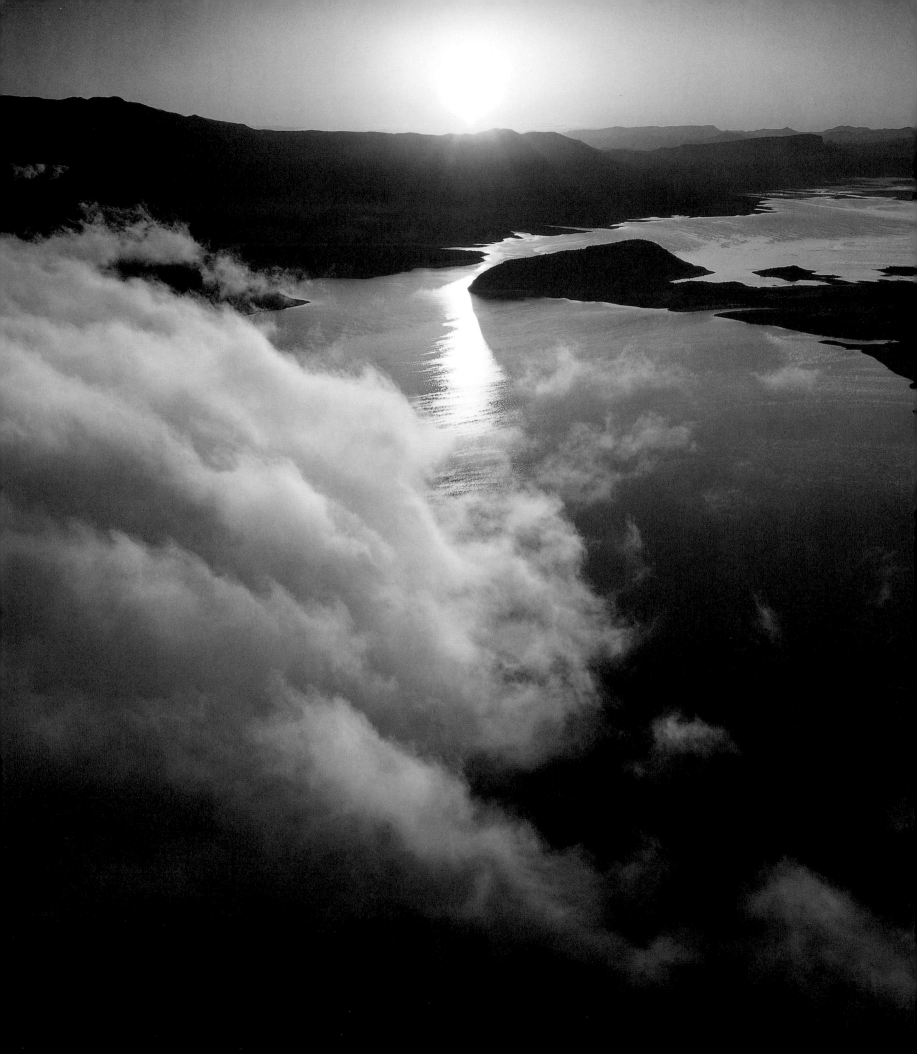

I strap the headlamp tight around my fleece balaclava, readjust the hole for my face, and step out into the chill. I'm feeling stiff from the long drive, and groggy. If I were home in bed, this hour of the night would be the time for my most vivid dreaming. Instead, I'm trying to find a place to take off.

The gate is chained shut, bound with a hefty padlock closed tight as a pit bull's jaws. I'm not surprised, but my spirits drop a little in the face of brute fact. I'm going to have to do this the hard way. A quick inspection shows I'll need a couple of wrenches, so I get my toolbox out of the airplane trailer. The road is quiet and empty. I need it to stay that way for ten minutes.

Working like a cyclops under the beam of my lamp, I take the hinges apart and wrestle the gate free of its nest of weeds. It pivots around nicely on the locked chain, and I lean it against a sturdy prickly pear cactus. After pulling my Bronco and trailer through, I put the gate back and redo the hinges enough to escape notice. No one has come by; the rest will be easy. Somewhere about a mile ahead there should be an airstrip.

The closest public airport is twenty-seven miles away over harsh terrain. This runway is the only place around here I can take off that I know. The aeronautical chart marks it as "private," but I know this is public land because I'm in Tonto

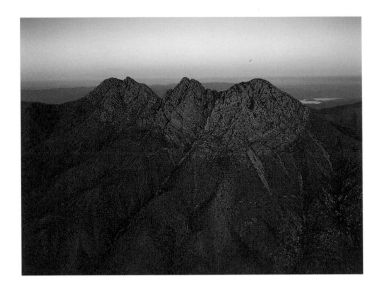

National Forest. Sometimes private airstrips are open to the public. Sometimes a visit is the only way to know for sure.

As I drive up to the flight line at the vacant airstrip, signs confront me. They insist I am not welcome. No one's around. It would be so easy. But I can't do it. To fly here now would be open defiance, and that's not the spirit of my mission.

I noticed a turnoff from the gravel road on my way in to the airstrip. I poke in with my headlights and discover a few open acres in the surrounding desert. Probably a staging area for some long-finished road project, judging by its emptiness and look of disuse. It's perfect for my purposes, and there aren't even any bristly signs telling me I shouldn't be here. I park the trailer and begin unloading my airplane.

It changes for different latitudes, but my rule of thumb holds true for the whole Sonoran Desert: when I can see the first tinge of gray light in the east, it will be one hour and fifteen minutes until sunrise. City dwellers never see this moment for the same reason they don't see many stars—urban twilight lasts all night long. But out here, deep in Arizona's interior mountains, its arrival is so obvious someone may as well have rung a bell. It's the end of astronomical night, the beginning of morning twilight, when the sun is eleven degrees below the horizon. To me, it means there's just enough time to unfold my

plane, take off, and fly to where I want to be before the sun comes up.

This morning, that would be above the west end of Theodore Roosevelt Lake. A late winter storm is on its way out after dousing the state with yet another shot of Pacific moisture, and I hope that dawn will reveal some low clouds straggling in the canyons around the lake. Even more, I'm hoping for snow on Four Peaks, the quartet of rocky summits that jag the sky in one last topographic hurrah before the land sags into the broad basins of the western desert. Yesterday I called a friend who lives within sight of the mountain for an eyewitness report, but she said all the high country was obscured in cloud. The temperature suggests the peaks might be white, but I have no way to know for sure. When it's light enough here to see for myself, it will be too late to fly up there in time for the alpenglow, that blush of first light that makes the rest of the day seem like overkill. The code of photographic preparedness mandates that I must already be airborne—in anticipation of whatever might emerge from the gloaming.

Because timing is so critical in my work, I've learned to read the twilight sky for all the clues it has to offer. The transparent desert air can be surprisingly nuanced. Wiped clean by the storm, this morning's atmosphere will be rife with markers.

For example, I know that when I can first detect a straw-colored wash at a hand's breadth above the horizon in the west, I have twenty minutes until sunrise on the ground. It's always a silent transformation, of course, but inwardly I feel as though a soft fanfare is breaking out when I see the western sky gradually divide into pink and blue. The pink is where the sunlight is shining into the upper air, and the blue is where the edge of the earth still cuts it off. Indeed, the soft line between them is the earth's own shadow, cast onto the curtain of sky. It will become more distinct and colorful as it sinks toward the horizon, until, at the first instant of sunrise, it will vanish from the sky. Most desert dawns bring this fleeting show, yet it always fills me with primal joy. It reminds me I live on a planet suspended in its own cocoon of faithful gases.

This is all yet to come. I'm still wearing my headlamp as I get ready to roll my plane out of its trailer. I pause when a coyote wails up in the hills south of me. It sounds close, quavering in the silence. Soon another tenor joins the solo cry. Suddenly the air is filled with voices. I can no longer tell where they're coming from. I feel as if I'm in the midst of an evangelical revival, where mysterious pathos is sweeping the throng. The coyotes are singing in tongues, and I'm the lone, dumb reprobate. Then, as abruptly as it began, it is over. Silence collapses on the land, leaving me aching for whatever cryptic message the coyotes delivered to the world.

The glow in the east reminds me how unstoppable the sunrise is, so I get back to work. As I rig the plane for flight in the dim light, owls begin signaling to each other like Apache scouts. Sometimes their low, unarticulated hoots dance right out on the edge of my hearing, and I wonder if I'm imagining them. But then one will call close by with a force I can almost feel in my chest, and answers boomerang through the distance. The sounds string a web around me, making this place feel local and known, even though I've never been here before.

Doves soon stroke the air with clucking and cooing. Gambel's quail call nearby, their voices soothing, almost conversational, yet slightly exotic. In the growing light I see the plump little birds scamper along the bushes at the edge of the clearing. When I step out of my trailer carrying a fuel jug, they run urgently, as if they'd rather not use their wings. Then, the whole bevy explodes into flight, and I nearly drop the jug from the scare. I smile at myself, no longer groggy. The desert is awake, and so am I.

It's time to start the engine, a moment I both love and dread. The sound of a newly alive airplane engine draws the land close. It means the whole skyline is my neighborhood. But it also cuts me off from my surroundings; I won't hear the birds again until I'm finished flying.

I wish I could fly without a machine. I wish my machine didn't make noise. But I can't and it must. So here I am, whispering apologies to the desert, turning my attention to the little motor that will bring me as close to my wishes as I'll ever come in this world.

My ultralight sounds almost quiet next to the din of the bigger airplanes most people know. And I've modified everything I can to dampen its noise even more—slower propeller, special muffler, bigger engine for lower power settings. But it's not just the hardware that mitigates my impact. It's the way I fly, too. I watch for people and animals on the ground below me and, if I see any, I stay high or go the other way.

Even so, I track footprints of noise over the land. They may be faint, yet their very presence implies all of civilization. Can I reconcile myself to this? I fly to know the land in uncommon ways, and thus to love it more deeply. I feel accountable for my freedom, my knowing, and my love because they come at a price. I always wonder if photographs are ample recompense.

As soon as I'm above the trees, it's clear that I'm not the only one awake so early. Across the draw, in the empty parking lot of the Grapevine boat ramp about half a mile away, I spot two trucks pulled together driver's-window-to-driver's-window. They're white, and I think I can make out some green trim and insignias on the doors. Their parking lights are on, so they must be inhabited. I turn away hard, and not just to preserve their peace.

Out over the lake, I scan the farther reaches of my newly enlarged view. The eastern sky is clear all the way to the horizon—this means the sun will rise bright as a welding torch. Low gray clouds are churning up into the canyons along the southern shore—weather! And Four Peaks is . . . bare. Oh well. I'll explore the lake instead.

Theodore Roosevelt Lake is shaped like an eagle in flight, wings outstretched, head down. It's quite large—twenty-three miles from wingtip to wingtip. The eastern wing is the flooded channel of the Salt River, and the western wing is the equally full Tonto Creek basin. The dam sits right at the beak, where the two come together. I'm about midway out the eastern wing.

The Salt River began backing up in 1911, when workers finished building the world's largest masonry dam just downstream from the confluence with Tonto Creek. They cut blocks from the nearby cliffs, and I've read that the rock in the dam is over a billion years old, chock full of fossil algae. It's strangely poignant: some of earth's most ancient life forms giving modern human society a chance to flourish in the desert. Without reservoirs like this one, Phoenix could never have become the marvel of prosperity that it is.

The Sonoran Desert has no natural lakes of its own. It has good groundwater, but not nearly enough for everyone now sucking at it. A lot of water must come from someplace else, and I'm over one of those places right now. Up here in the mountains, rain and snow keep the rivers flowing year round. When Phoenix put a stopper in the gorge below Four Peaks, it got two things in return: no more floods, and no more droughts.

Even in this weak light, I can see the ghostly bathtub ring that runs around the lake like a contour line on a topographic map. Where the shore is steep, the ring is narrow. Where the shore slopes gently, like a beach, the ring is much wider. Either way, its story reads plainly from above: rains come to the mountains, the lake rises; Phoenix takes a long sip, the lake drops. The ring itself is a dead zone, strewn with saguaro cactus skeletons, where the living desert has surrendered to the caprices of a distant and voracious thirst.

At the moment, my left arm is turning red. The lurid new color rakes over the robin's egg blue of my flight suit from behind, as if I have a blast furnace at my tail. A thousand feet above the lake, I turn the plane around to see what's happening. In the east, the sun is spilling over the horizon. In the west, low along the horizon, the sky is split: deep blue below, bright pink above, and where they touch each other, they glow as though they're electrified. The edge of the earth's shadow has landed on me.

A minute later, it lands on the clouds billowing up below me, transforming them with a bath of shameless rosy light. At lake level, these clouds would just be patches of dull fog, but up here, they look like a dream of heaven come to life. I can justify a little monkey-wrenching for the sake of pink clouds. They make me feel that the world really does have magic in it, that hope is a reasonable attitude. I'm reminded that somewhere on the planet at any given moment, pink clouds are always real. This comforts me. In those places and moments, all the sterner facts of day and night are merely remembered. And here I am, as real as these pink clouds now, leaning out into space against my shoulder harness, gliding through wisps that spew off their tops like flares rising out of the sun.

I skim across a vaporous dome, then bank around to see the traces of my passage. There they are—two long hollow tubes of cloud spinning like suds in a drain—my wingtip vortices. I know they're always behind me because sometimes I fly right into them when I'm circling in the sky, feeling a sharp bump as I pass through like a boat crossing its own wake. But until now, they've always been invisible.

The sight of the top of a cloud with my wing prints in it trips something in my brain. I changed this cloud! What if I hadn't gotten that gate open this morning? What if Four Peaks had had snow on it? What if I hadn't been born? That cloud would probably still be here, but it would be different. This swirling, silent universe, basking in the new dawn and unseen to anyone below, includes me too. I am rapturous as I feel our worlds intersect. I reach my left hand out into the great ocean of sky in front of me and fly toward the cloud again. I approach it in slow motion, like a snowflake falling earthward. A thrill rises with the coming immersion. How long will I be inside? What if the carburetors ice up from the moisture? What if I lose my bearings? What if there's someone right on the other side when I come out? Too late now!

Dank chill engulfs my face. My eyelids dew up, and I nearly choke on the cold wetness flooding my lungs. The plane wallows as it joins the cloud's strange aerodynamics. There is no space, no color. I might as well be sitting inside a snowdrift. I'm coasting on my leftover sense of up and down, and it's running

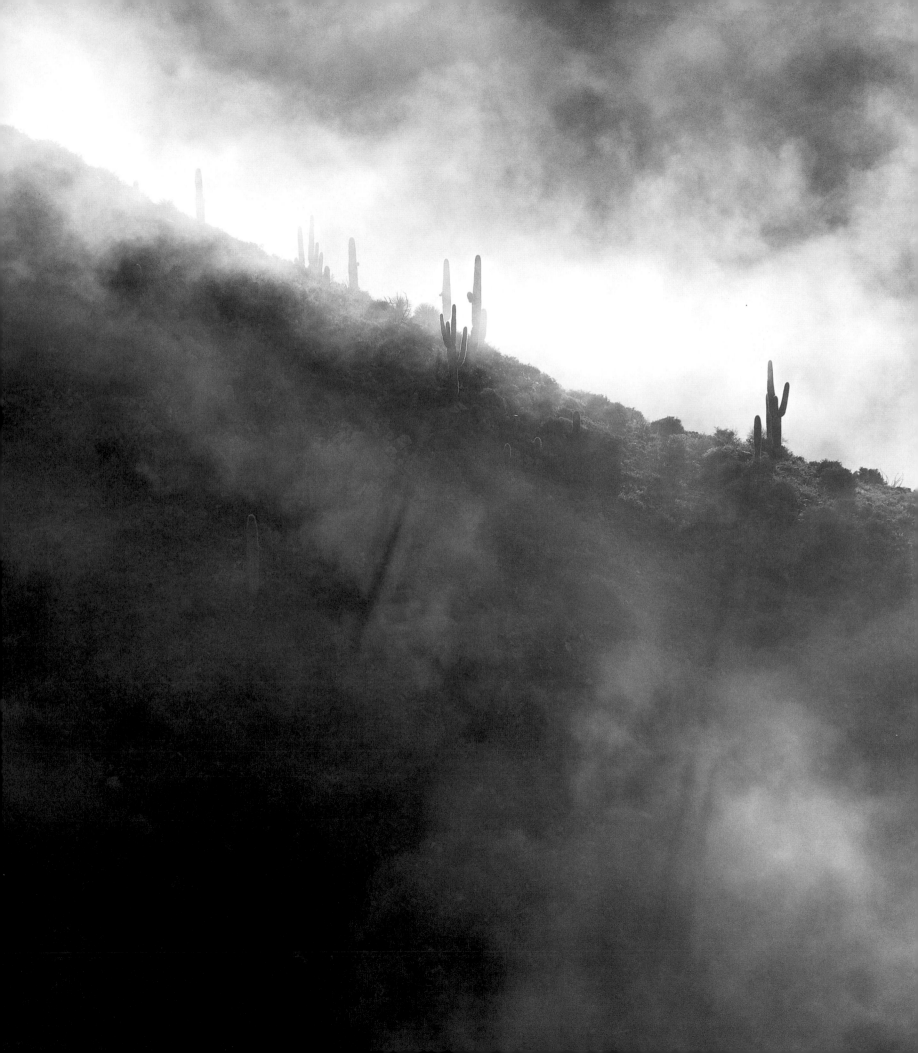

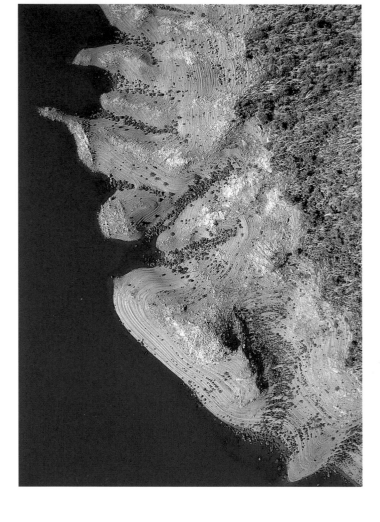

them, touching them with wingtips and fingertips, feeling first-hand their self-assured but always-adapting choice of where and how to exist. Clouds remind me how to live.

I am intent on photographing now. The color of the light is beyond belief, and it won't stay that way long. This is a rare opportunity in the desert—to work above low clouds, including them in the foreground, and still to have a good landscape in the distance. I waltz among their contours almost delirious with freedom. If these were real hills, there is no way I could be flying this close and hope to survive for long. The risk of collision with terrain always trumps everything else, including setting up for photographs. But here, I can scalp through the tops of hills, even disappear inside one, if I want to place myself just so for a picture on the other side.

Sunlight glints off the water through a gap in the clouds, and I see a surface painted by wind. On what would otherwise be a calm morning, I know the air is alive with movement because of all the high country around this lake. Far up on the slopes of the surrounding mountains, cold has been soaking into the highest rocks all night long and chilling the adjacent air. The air gets heavy, and begins draining down the mountainsides like thick, invisible syrup. It gathers mass and momentum as it descends. By the time it pours into the low-lying canyons and basins, the cold air is so forceful that it has become a gusty wind. When it reaches the lake, it can go no lower—unless it finds its way over the dam. This morning Roosevelt Dam is probably the windiest place in the state. And below it, all through the snaking canyon, spindly stalks and branches are waving furiously as the mountain winds flow down toward the open desert.

But there's not enough room for all the heavy air to get out of the basin through that single outlet. Like a horde of football players converging on one little ball, the winds in the center of the lake pile up on each other and start pushing skyward. They're propelled by the constant arrival of even heavier, colder air behind and beneath them. Clouds are forming over this pileup in mid lake as the renewed chill of altitude wrings mois-

out. I can feel terror scratching at the edges of my mind. I've flown inside clouds too many times to count, but that was with gyroscopes. Here I am, sitting on the end of a rail without even a magnetic compass. At least the engine sounds as though it doesn't know the difference. Now it's growing lighter. Everything is the color of orange sherbet. It's too bright. I'm inside the sun, except this is COLD! WHOOSH...the world snaps into focus like vision itself being born. I'm out.

Clouds are serene because they are completely spontaneous. They're part of something larger and more open than anything else on earth, yet each one is exactly as it needs to be in any given moment. Why is a cloud here and not there? Why this shape instead of another? It's one thing to watch them from the ground and wonder this. It's quite another to be up here among

ture out of the air. The slow-heaving cloudscape around me holds stories of long and wild journeys, if only I can read them. The reason the clouds are here this morning, and not most mornings, is the recent storm. The land is wet, the air is wet. The land has rivers for its overflow, and the air has clouds.

I turn toward the rugged mountains southeast of the dam, where shreds of mist drift like specters among the precipices. Every branch and spine seems to hold its own little dewdrop sparkling in the brightest light imaginable.

Saguaro cacti rise out of the fog in striking numbers. I glance at my wrist altimeter: 3,670 feet. They must be at the limit of their range up here, but they stand in dutiful phalanxes, holding ground for the Sonoran Desert empire. They're growing only on the south-facing slopes, where they collect enough extra sunlight to survive the chill of the heights. I, too, prefer to face the sun for its infusion of warmth in the icy air, and drift ever southward with my bias.

I photograph as if I'll never be here again, but before long the light has grown too strong. The magic is out of it and, unlike my eyes, the film can no longer see into both shadow and glare at the same time. Light changes fast on a clear morning in the desert. I stow my camera in the pod beside me, unhook the control stick from my leg, and look out across Roosevelt Lake. The clouds are nothing but a memory. The sun is drying up the air and baking the land with light. I want to return to earth.

As far as I can tell no one is waiting for me—or even watching me. Just the same, I break the plane down and load it in the trailer with all the haste I can muster. It just seems to make sense. I can't relax until that locked gate is behind me.

Out at the highway, I park my rig as if I just pulled off to check the tires. Then I put the gate back on its hinges as quickly as I can; there's no way to hide what I'm doing. I work intently, trying not to think too much.

Then I hear the thin hiss of an approaching vehicle. With each split second I'm calculating whether or not it's slowing down. The tires are loud; it's bigger than a car. I still don't look. I'm turning down the last nut . . . so close.

It's a Forest Service ranger. I'm dead.

I drop my tools in the weeds and walk casually over by my truck.

I answer his questions straight through, with eye contact.

"Tucson, sir . . . Just checking things out here . . . No, there's no trouble . . . I understand . . . Oh. Two hundred fifty dollars? Hmmm . . . Okay . . . Thirty days . . . No, I won't ignore it."

The officer goes through his paces as though it's a practice run, dry as can be. He doesn't ask what I was doing. He doesn't ask what's in the trailer. He doesn't seem the least bit interested. He hands me the citation and drives off slowly.

I feel a little vertigo as my questions flood in. Does he even know I was flying? If so, why did it take him so long to get here? It's been forty minutes now since I landed. Was he watching me the whole time? Did he wait to make sure he spared me the humiliation of being caught with the gate off its hinges? Or did he just happen to come along? If so, there's no evidence I was inside the locked gate, certainly no evidence of what I was really doing. Maybe I should've contested it. But then if he *had* seen me, I would've been the fool. And maybe in a lot more trouble. I don't know. I'll never know.

I study Four Peaks, sixteen miles away on the hard blue horizon, as I walk over to pick up my wrenches.

I'm smarting from the fine, no doubt about it. I look at the paper. "Operating in a Closed Area," it says. I remember the coyotes . . . the dawn chorus of birds . . . the pink clouds . . . the wind on the lake . . . the saguaro forests. How much are they worth to me? Today, I guess I have an answer.

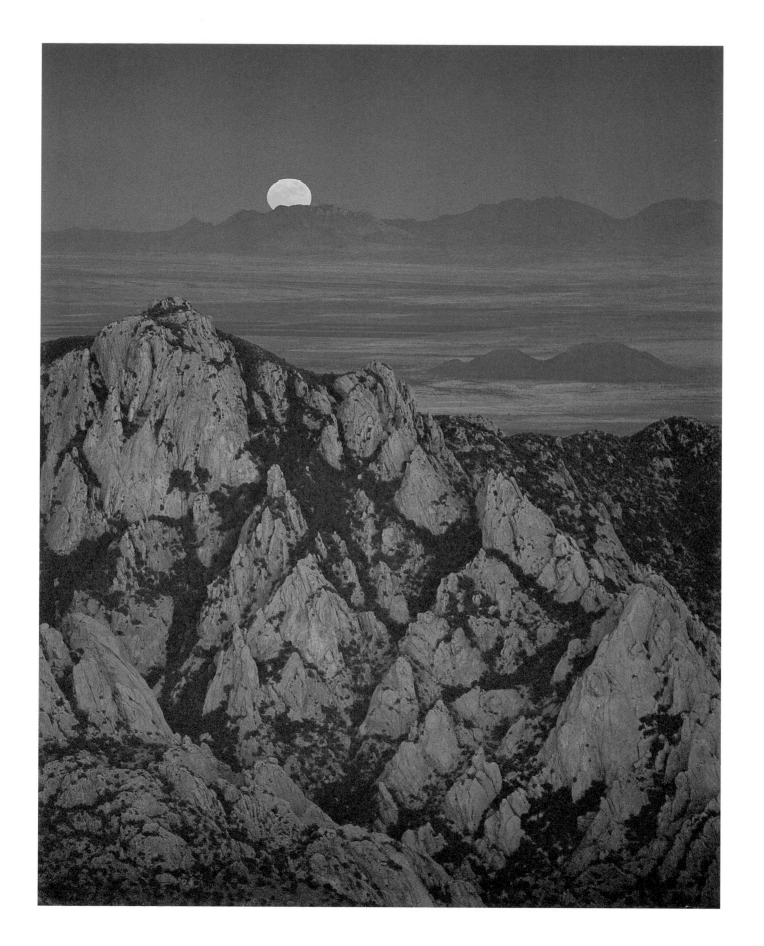

Mount Glenn in the Dragoon Mountains, Arizona

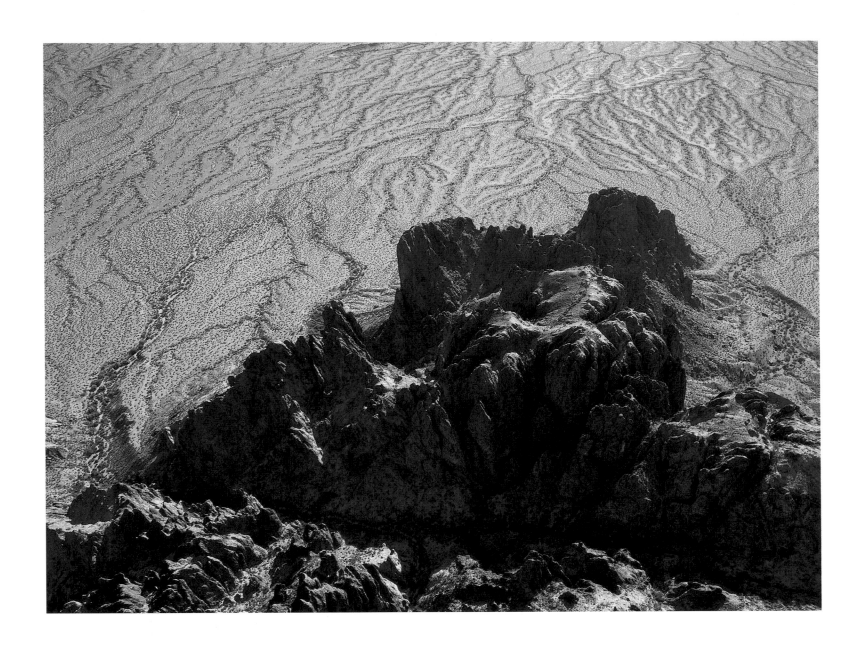

Eagletail Mountains Wilderness, Arizona

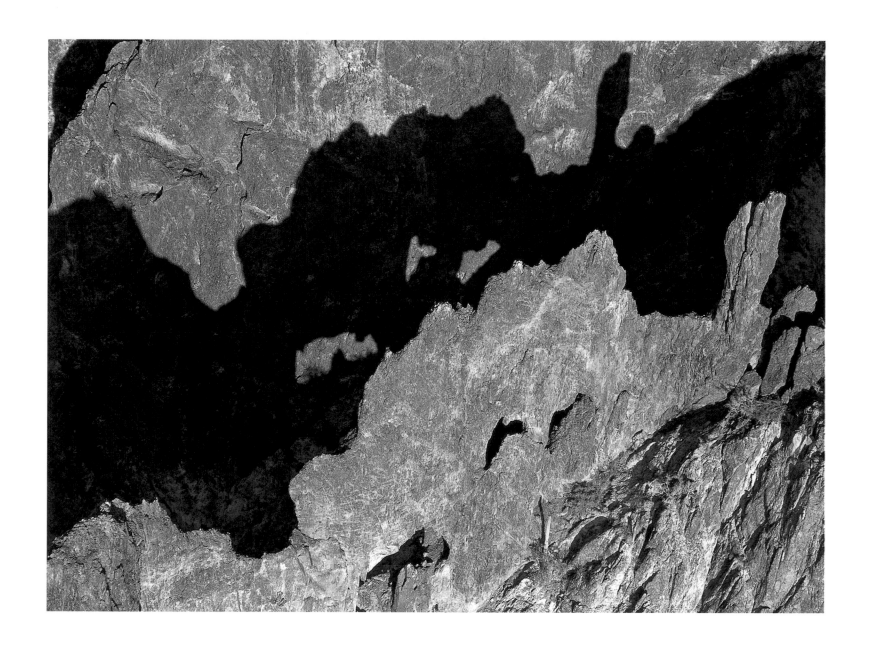

Rock windows in the Eagletail Mountains Wilderness, Arizona

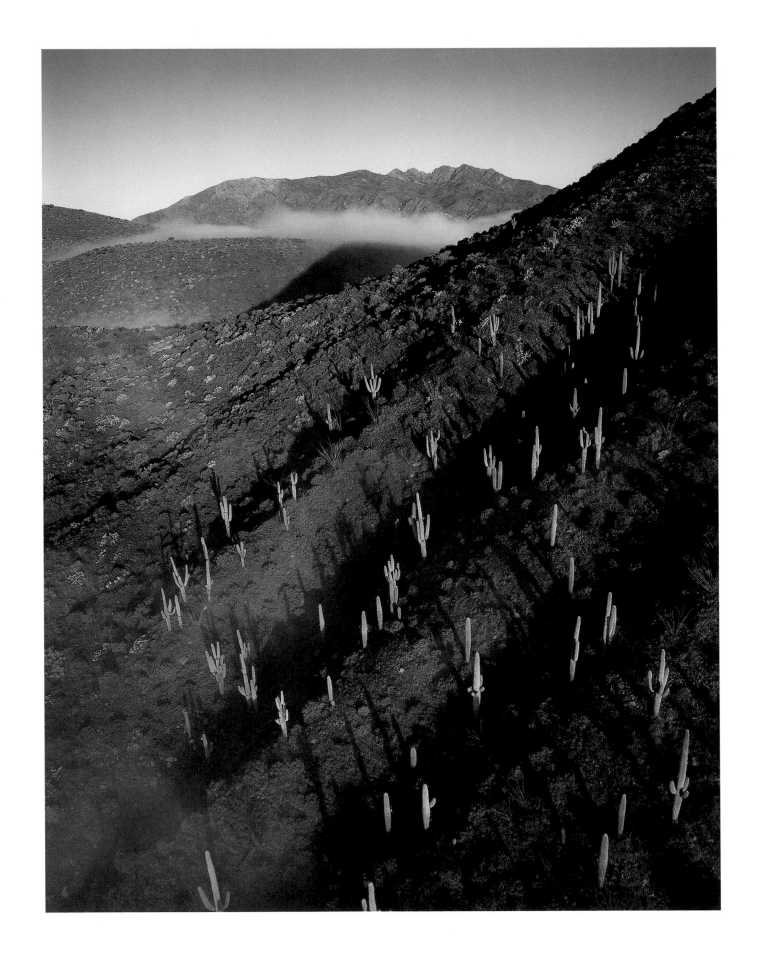

Two Bar Ridge in the Tonto National Forest, Arizona

Ocotillos with Mexican gold poppies in Wild Hog Canyon, Arizona

Cement plant runoff, Tucson, Arizona

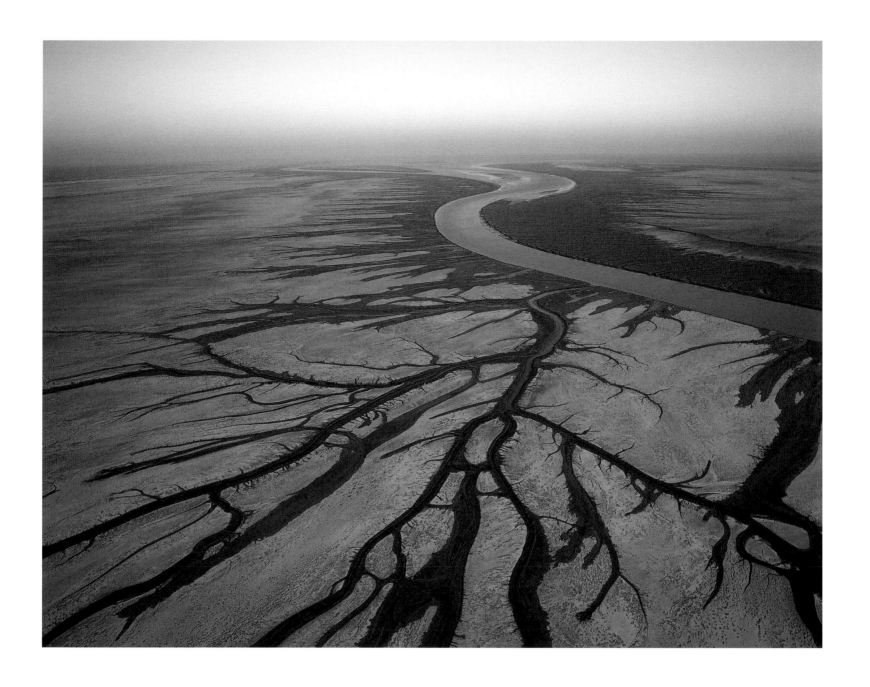

Colorado River delta salt flats, Sonora

Power lines and the Tortolita Mountains, Arizona

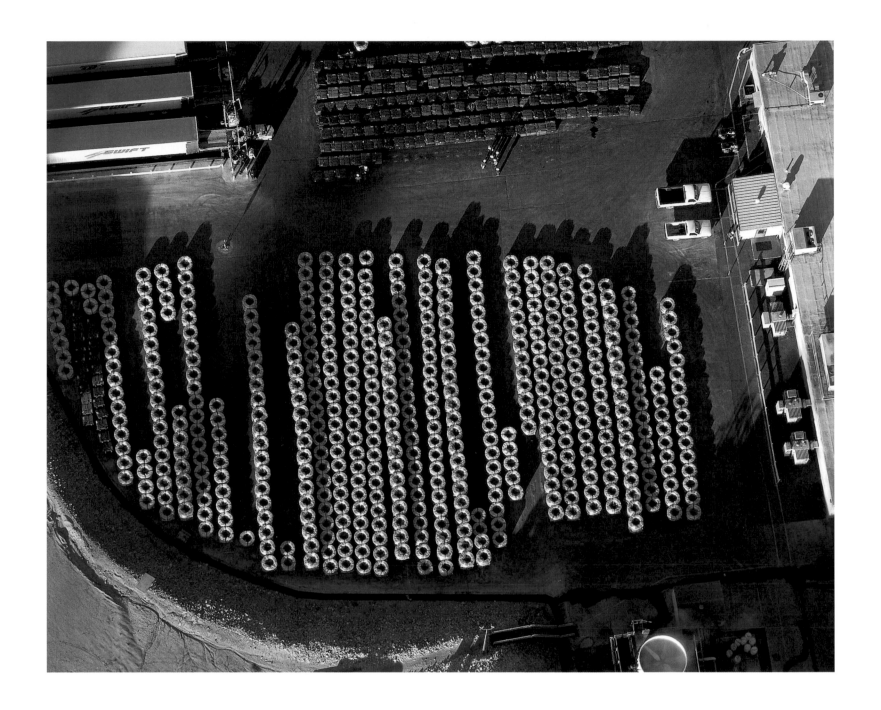

Coils of pure copper rod, San Manuel, Arizona

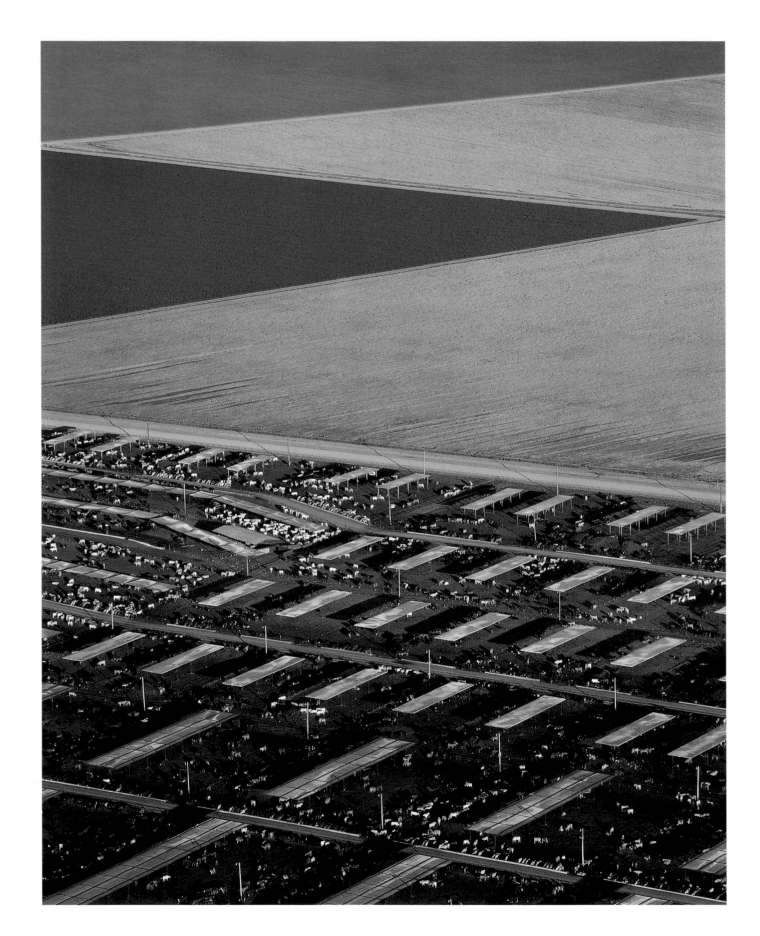

84

Feedlot, Red Rock, Arizona

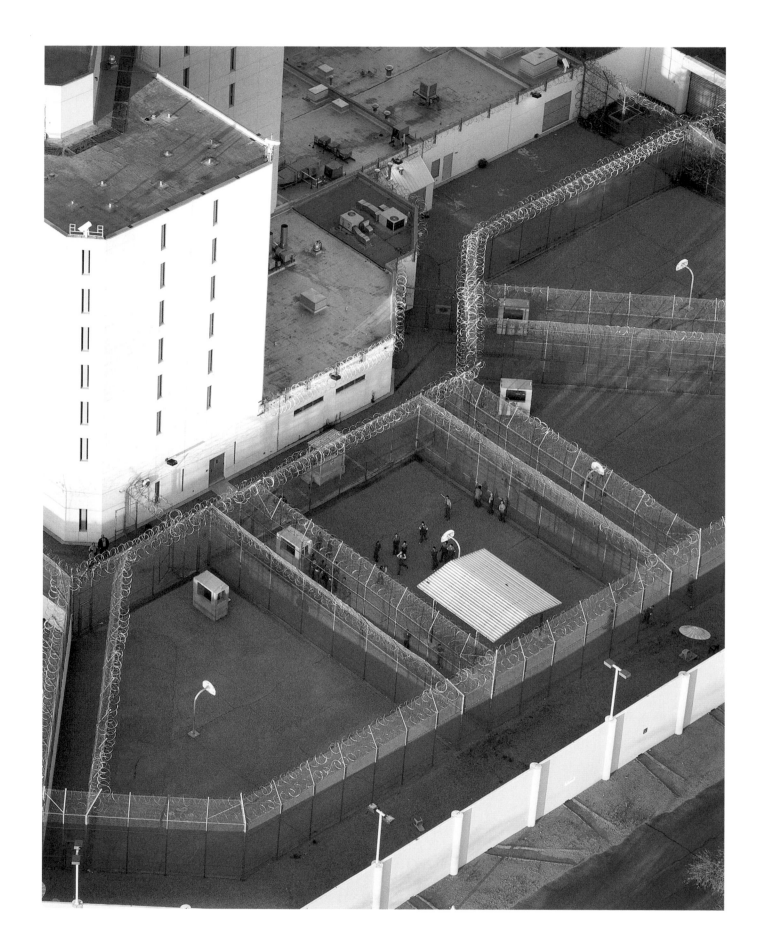

85

Pima County Adult Detention Center, Tucson, Arizona

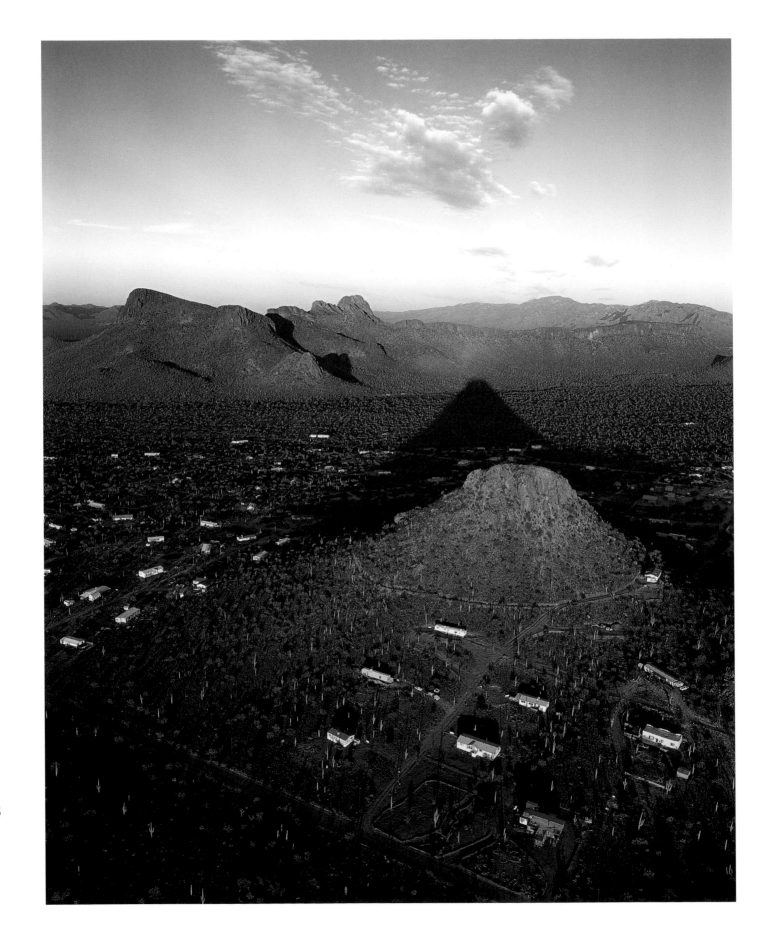

Wildcat development near Tucson Mountains Unit, Saguaro National Park, Arizona

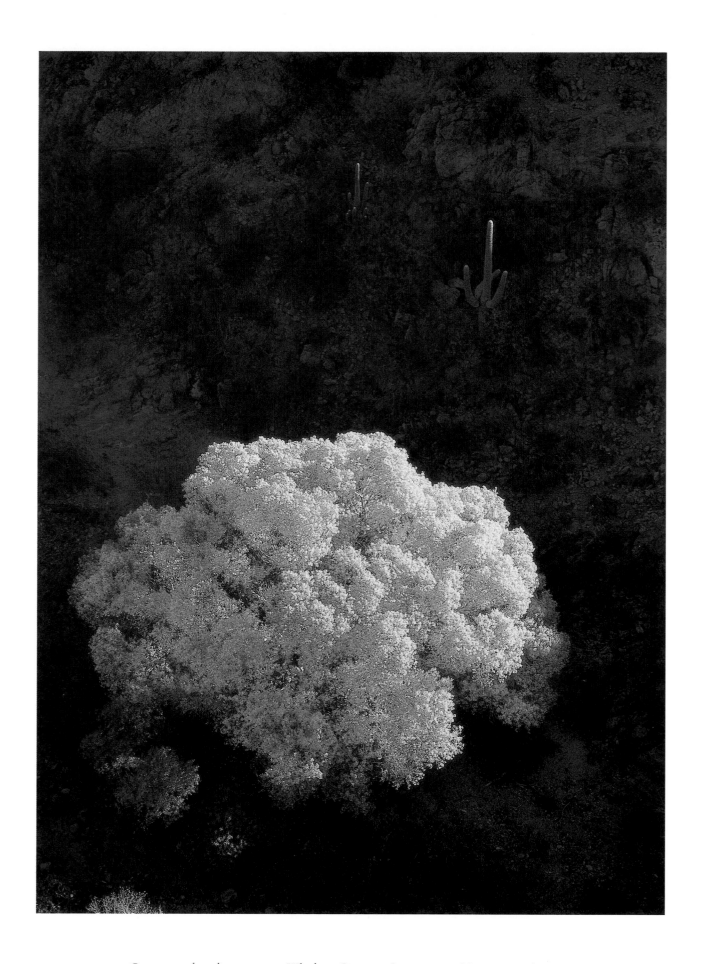

Cottonwood and saguaro in Whitlow Canyon, Superstition Mountains, Arizona

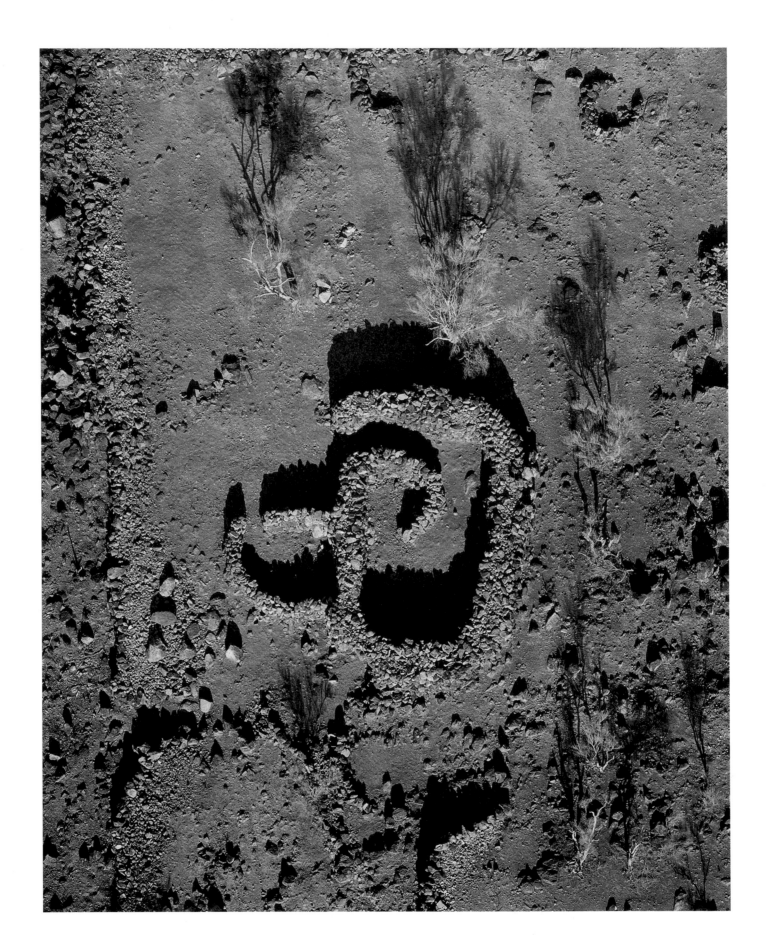

Prehistoric compound on Cerro de Trincheras, Sonora

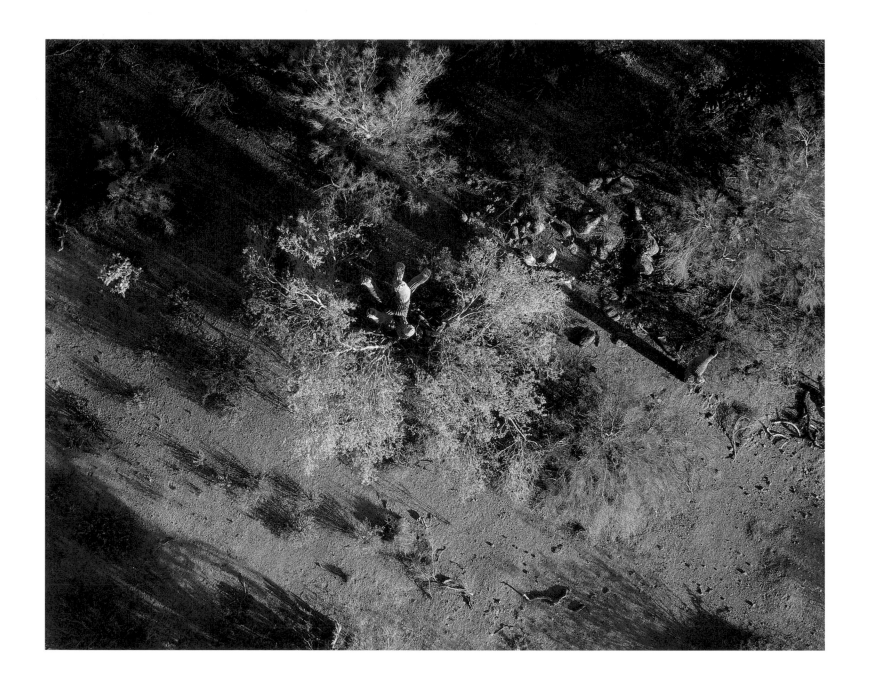

Saguaro and ironwood tree in bloom in the Silverbell Mountains, Arizona

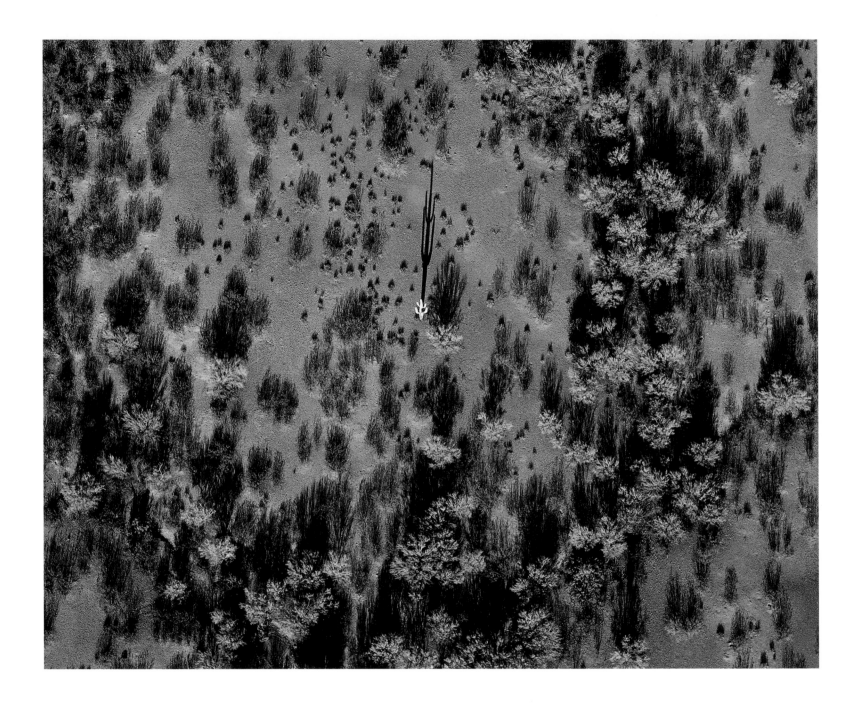

Saguaro and palo verde trees in Avra Valley, Arizona

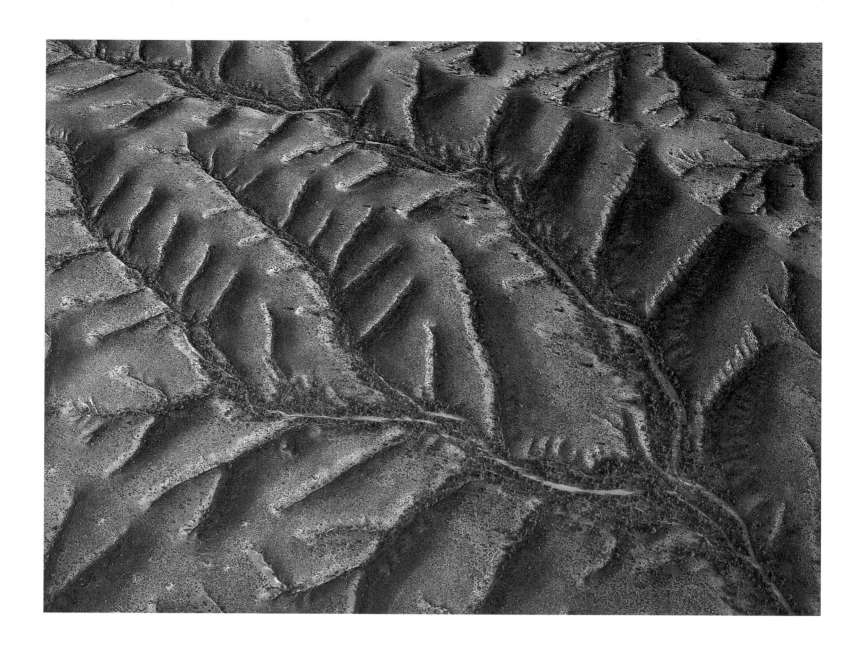

Cienega Creek watershed in Empire Cienega Resource Conservation Area, Arizona

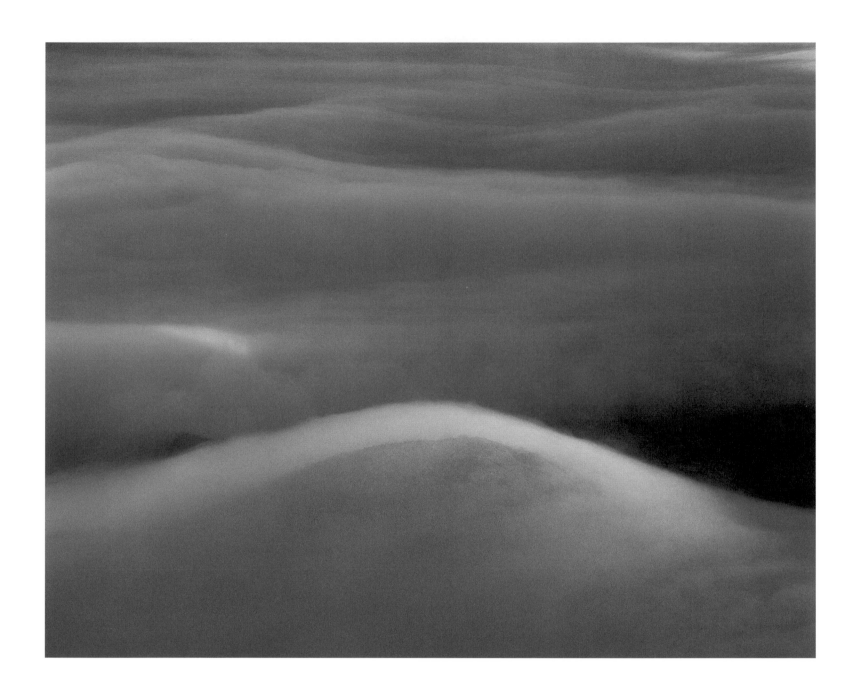

Ground fog obscures Camels Back and the Sulphur Springs Valley, Arizona

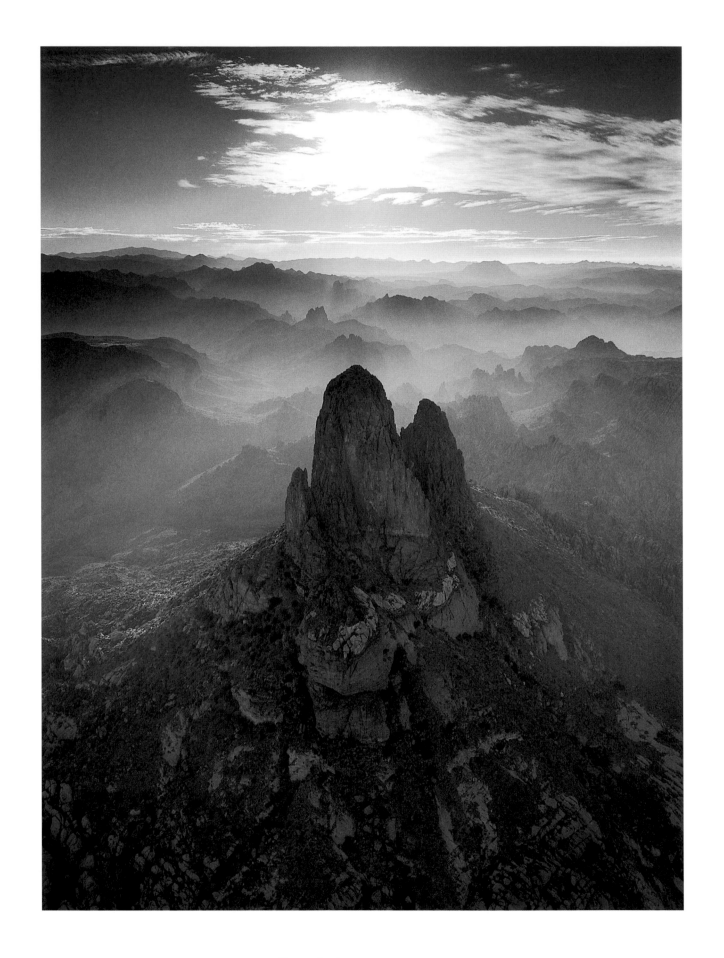

94

Weavers Needle in the Superstition Mountains, Arizona

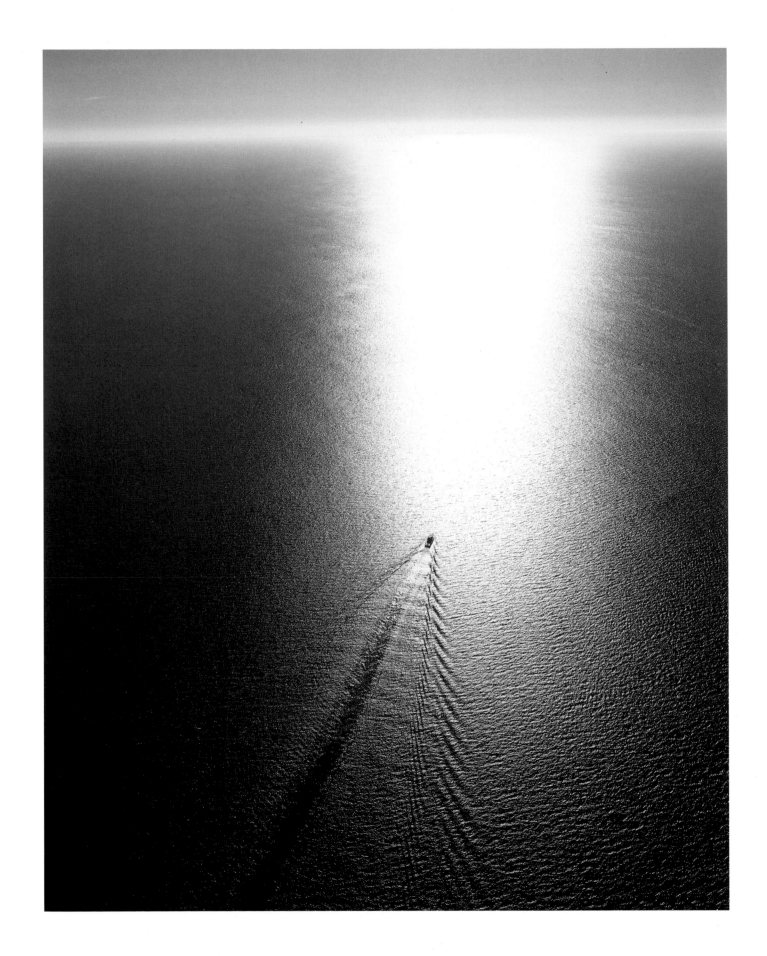

95

Fishing boat at Puerto Peñasco, Sea of Cortez, Sonora

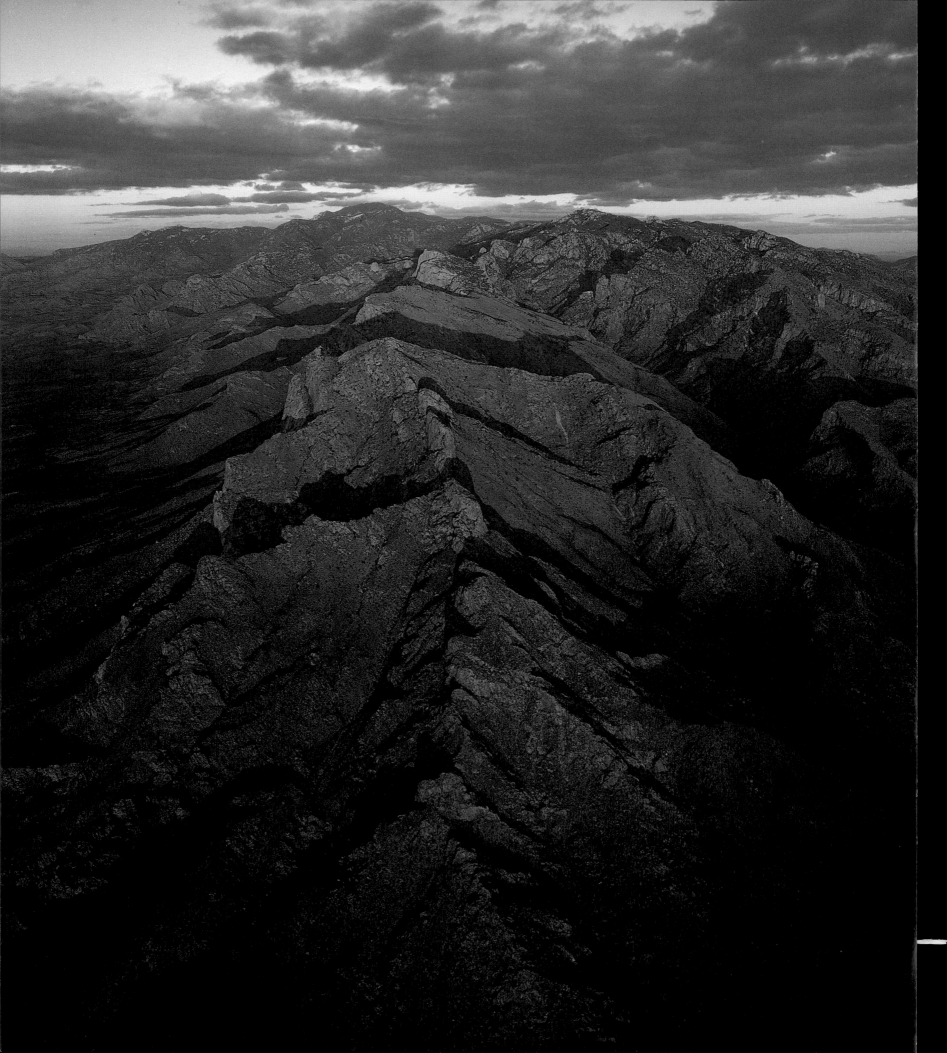

FINGER ROCK

FIRST CRASHED AN AIRPLANE when I was thirty-three years old. It was my own plane and my own fault—a simple affair, really. Since it happened on the dirt runway right outside the hangar where I had built the plane in the first place, my friends had all the wreckage put away by the time I got back from the hospital emergency room. I had a sore back, nothing worse.

My inner torment, however, wouldn't go away. I had been flying for eighteen years at the time of the crash. I was happily making a living as a corporate pilot, with six thousand accident-free hours in my logbook. I knew better than to do what I had done.

It was a bitter irony, and one of flying's cardinal sins: I had turned a practice emergency into a real one. I was landing my plane without the engine running, just so I would know what it was like. These deadstick landings are something every pilot must be able to do because, if the engine ever quits during flight, they're how you get safely back to earth. But an idling engine simulates a dead one well enough, and almost no one actually shuts down a good engine for practice—unless he wants to know beyond all doubt that he can handle it.

This was part of the bargain, I figured. I'm going to ask my plane to do things that aren't normally done, and I will need to know that I have the skill to match. Two hundred feet over a

97

canyon stream with the only landable spot on a sandbar *behind* me was simply not when I wanted to be making my first pinpoint, deadstick landing. So I trained zealously, switching the engine off at ever lower altitudes, always demanding a U-turn in the air, for complexity's sake, in order to reach my spot on the ground. Eight landings had gone perfectly. The ninth nearly ended my life.

I had chosen a real obstacle course. The runway itself was just a dirt track, with the forty-foot-high hangar squarely on the approach path, and a hundred-foot radio tower nearby, thwarting shortcuts. I had no choice but to get it right, and the realism suited my purpose.

The sun was high enough to begin stirring a breeze, and the shadows of morning cumulus clouds were starting to blotch the land. I was too naive to notice the warning: the atmosphere is coming alive, so you'll need extra margin for surprises. When I flew into the sinking air, the engine was already off, the tower already blocking a straight bolt for the runway. I was too busy trying to keep from hitting the hangar to think about restarting the engine.

I have relived that moment so often that I'm surprised I didn't see my future self floating in the air beside me, calmly telling me what to do differently. But at the time I didn't even know how much trouble I was in. I thought I could make it until two seconds before I didn't. When I tried to level off for touchdown, I discovered I had used up all my extra flying speed just to get through the sink. There wasn't enough left to pull up with. I had no time to be frightened; I just flew helplessly into the dirt.

The impact broke a spell, one I recognized only after it was gone. I had felt completely safe in airplanes. Like most pilots, I believed my choices and actions could make all the difference in an environment fraught with danger. Dependable machines, relentless training, and a few thousand hours of uneventful flying engender a certain confidence.

Somewhere along the way, though, solid ground had become an abstraction for me, too much like the virtual reality displays in the flight simulator. I knew in my mind that real dirt was out there, but my body began to lose touch. As I lay in the back of the pickup truck, bouncing along the road to the reservation hospital, I stared at the thickening clouds and felt a clear new message telegraphing up and down my spine: I can die.

It was fitting, I suppose, that I should discover this fact in an airplane specifically meant to connect me with my surroundings, but I was never the same again. I had to face the wreckage (I rebuilt the plane). I had to face my derailed dream of making art in the sky (I decided to move gingerly back on track). And one day, I had to get back in my plane and fly.

I couldn't hide inside the cockpit, because my plane doesn't have one. It's just a seat in the open sky, where the terms of existence are so stark they can sandblast my soul, if I'm not ready. If I am, the magic of going aloft is unlike anything else, which of course is why I didn't give it up, even after such a close call. But when I took to the air in my newly repaired plane almost a year later, I felt older, more cautious. The magic was still there, but I knew as never before that every sweet moment has its own dark underbelly of sorrow.

When my mother, who lives in Pennsylvania, heard that Holly and I often come upon rattlesnakes during our daily walks in the desert behind our home, she asked, "Oh, Adriel, how can you even go out of the house?" It's like that with flying. For someone who doesn't embrace the wonders of the sky, the thought of any mortal danger there can turn the whole place into a menace.

In reality, ultralight pilots cope with the threat of engine stoppage the way hikers deal with poisonous snakes in the desert: they accept that they're an inevitable part of the experience, learn their warning signs, and know what to do if the worst happens. When it finally does, it's almost a relief. This was certainly true of my crash. I eventually came to recognize that I had virtually brought it on myself just so I could face down my worst fears, once and for all.

By the time I came to live in Tucson, I was a seasoned ultralight pilot. I knew I might have to make a landing anywhere, at

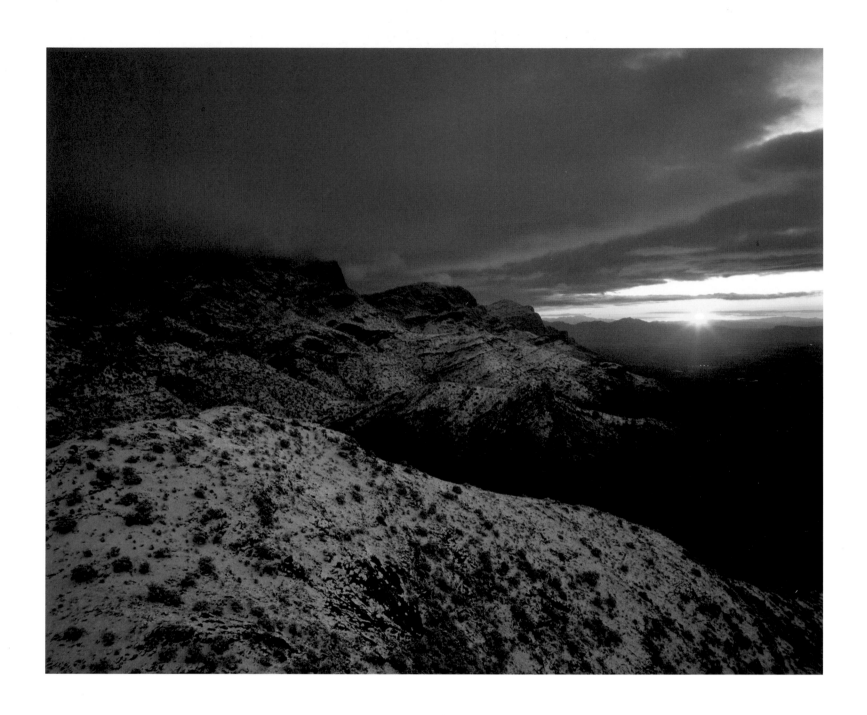

a moment's notice, and I also knew I could do it. The desert around here, however, looks awfully woolly from a few hundred feet overhead. The same profusion of plants, which makes the Sonoran Desert so remarkable among deserts, also makes it especially forbidding to a pilot with a dead engine looking for a place to land.

I didn't know Janice, really. She was one of many faceless characters Holly mentioned when she talked to me about her life at the Birth Center. Janice was a nurse, recently moved here from Delaware with her family—that's about all I knew. But when I heard that her son was killed, I felt the tremors down deep.

The evening of the memorial service, I watched Holly drive away, and then I went up on the hill behind our house. We have three dogs planted in the ground there, two under an old palo verde tree, and one out in the open among the brittlebushes. I loved those dogs, raised them and lived beside them, held them while they died, and then buried them. I like to sit by their graves when I need some perspective.

The police surmised that Kenny was going around forty miles an hour when he lost control of the car on the patch of gravel. The mesquite tree that he hit was destroyed by the impact; how his girlfriend survived is a miracle she will always ponder. Kenny had graduated from Mountain View High School two months before the accident.

I hovered safely outside the gaping hole in Janice's life. I knew enough about what she was going through to be grateful that I had no more than a passing acquaintance with her situation. I knew that once the ground opened up underneath your feet like that, you never stopped falling.

I settled down on the dirt beside the most recent pile of stones, facing east where I could watch the light deepen on nearby Pusch Ridge. This was the same time of day when, years before, I had come down out of the woods and found a group of neighbors huddled on the bank of our farm pond. It was early October in the orchard country of southern Pennsylvania, and I was pretending to be young Daniel Boone—until I saw my brother stretched out on the grass. They had already tried everything they could to bring him back to life, but the pond had kept him too long. His second birthday was four days away. We had a funeral instead.

Seven years later, Pastor Rosenberry phoned our house in the middle of a Tuesday morning in July. He asked my mother if the whole family was home. He'd be right over, he said. She rounded up my two sisters and called my father and me in from the barn, not sure what was going to happen. When Pastor Rosenberry arrived, we were all waiting for him on the front porch. His eyes were red, and he didn't waste words. My older brother had been killed last evening on the farm where he lived in upstate Pennsylvania. We listened in stunned silence to the details of the accident. As farmers ourselves, we could imagine a tractor rollover only too well.

I knew about crying until I hardly cared if I took another breath. About yanking over and over on the chain of events leading up to the critical moment, desperately trying to find a weak link that would break and let loose a different future. About racing back to the last words I said, and they said, and clinging to them with a grip out of all proportion to their original intent. I knew about not having a chance to say goodbye.

When Holly got home from the memorial, we went out for a walk in the gathering dusk. She told me about Kenny's remarkable poetry, the loving memories spoken by relatives and friends, how his younger sister didn't seem fazed by the emotion of the event yet. I talked about losing my own brother at that age, how so many of those feelings can go underground to get sorted through, over the lifetime ahead—or not. With a daughter the same age as Kenny, Holly needed to talk, too, about protecting and letting go, about coping with unfathomable loss.

It was over a year later when she asked me, "Do you have any pictures of Finger Rock?"

"No, I haven't worked over on that side of the mountain yet. Why?"

"Janice was asking. Apparently that was one of Kenny's favorite places, and they want to spread his ashes there. They'd like to have a nice photograph of it."

Holly had told me about Janice's recent hip replacement. I remembered it because it seemed so soon after losing Kenny. I wondered at the time how much hardship one person could bear. Now, I couldn't help but wonder how they planned to get the ashes up there.

Holly said, "I don't know. I guess Gene would hike up there himself."

I'd flown by the pinnacle high up in the Santa Catalina Mountains. Although Finger Rock is a familiar landmark on the northern skyline of midtown Tucson, it's not what you'd call accessible. It stands nearly four thousand feet above the city.

"What if I'd fly up there and do it from the air?" I asked impulsively.

Holly looked at me a moment, then said, "You know, Janice might like that idea. I'll ask her."

At first, the plan was that she and Gene would see me off from the little private airpark north of our house, then drive around the mountain to the base of Finger Rock. I would bide my time in the air until I saw them arrive, then scatter the ashes while they watched. Since I had to make the decisions about weather, we left it that I would call them—probably on short notice.

After I made three attempts to set up the flight, Janice finally admitted she couldn't go through with it yet. I had no interest in forcing the process, so I let some months go by. The holiday season came and went, and the fresh mood of a new year seemed palpable. Janice called one day: yes, she was ready, but could she fly with me herself . . . and Gene too?

I can carry a passenger in my plane, but the chemistry changes for me. My old executive pilot sensibilities kick in, and I become very conscious of the quality of the ride, especially for a first-timer. Also, the plane suffers a significant loss of performance when it carries the weight of a second person, and I have to readjust my thinking to compensate. And there is the more important matter of responsibility. Am I willing to take on the burden of another's welfare in such a risky environment? It all comes down to who and why, where and when.

In this case, the request was a perfectly natural step. After all, if it was me, I would much prefer to scatter the ashes myself rather than watch someone else do it. I had made the original offer for reasons that became stronger and clearer to me as time went by, so why not this? The mountain? I knew the wind could get riled up by the big rocks, but I also knew that often in the mornings the air was tranquil, even close to the cliffs. It would just have to be the right morning.

Winter was a good season, and a Saturday in late January looked like a good day. The price of a strong engine and a smooth ride would be cold air, and Janice and Gene agreed to it. I set up the plane the night before and tied it down at the airport, so I could launch at sunrise with little fuss and go check out the flying conditions around the mountain before they arrived. I had another reason to fly alone first, too: I'd never thrown ashes from a plane.

My flight instructor told me once how he had been hired to fly down to the Chesapeake Bay for this very deed. The principals showed up at the airport holding a brown paper bag. When Keith offered to take them along, they quietly declined. Maybe they were just fulfilling last wishes out of obligation, maybe there were no heartstrings involved, but Keith was left to figure out the details of the task for himself. He flew far out over the water, as requested, and throttled back so he could open his side window. He unlatched the brace, letting the Plexiglas panel lift all the way up against the underside of the wing and stay there, the way you do for photography. Then he got out the paper bag.

He wrestled it every which way into the wall of wind filling his window, but no matter what he did, half the gritty stuff came blowing back into the airplane. He ended up digging a shop rag out of the glove box to wipe his face clean. It was a long ride home, he said, and he didn't know whether to feel angry, sad or nauseated, but when he landed, he didn't have the heart to hand the plane over to the line crew, so he got the vacuum and cleaned it out himself.

I wouldn't have that sort of trouble, because my plane has no inside. But I did have another problem. On my plane, the seats are in front of the propeller, so anything that goes overboard has a chance of hitting the blades. If it's something unforgiving, like a big bolt or a roll of film, the propeller could

disintegrate, throwing the engine out of balance so badly that it could be torn off the airframe before I had a chance to shut it down. At that point, the plane would probably be uncontrollable, and the only hope left would be the parachute.

However, I had a hunch that aerodynamics might help me out. Before I left for the airport, in the gray light of early dawn, I filled a mayonnaise jar with sand from the wash. When I got up to altitude, I slowed down and unscrewed the lid. Just as I thought—the contents stayed put. Forty-five mile-per-hour wind wasn't enough to suck them out. I turned around in my seat so I could see all the way to the tail, and then I extended my arm and slowly tilted the jar. Sand started spewing out into the airstream, passing well outside the ghostly propeller disk. The few sticks and stones tumbled harmlessly down into the void. A real-life wind tunnel was proving my plan safe.

The air was quiet all the way up to seven thousand feet at Finger Rock, except for a layer of mild turbulence at four. The engine was full of pep, running smooth as a sewing machine. I was relieved to have this chance to check it all out ahead of time. We were about to do something extraordinary, and I wanted a clear mind.

"I have my son in my pocket," Janice said, patting her leather coat. Her eyes were moist and red as she told us how hard it had been to get to this point, how she hardly slept all night worrying about the flight and the final letting go. Holly and I were grateful for her stalwart directness. Getting ready for a ride in an ultralight is usually fun, with silly jokes bouncing around to ease the tension. This was different.

"I got the urn down and divided up the ashes while she was at work," Gene offered gently, "Because I knew it would be too hard for her." He was dressed for North Dakota. Hands stuffed in his pockets, he gestured stiffly with his elbows as he talked. "Eventually, you know, we want to take some of the ashes to other places, but this is the first time we've handled them."

The sun was now out from behind Mount Lemmon in the Santa Catalinas, and warm light flooded the east side of my trailer. Holly suggested we move over there, and as we came around the corner we saw why. Two candles stood on the tarmac. They were the sort you see in little roadside shrines and Catholic altars around the Southwest, tall glass jars filled with wax and decorated with an angel and a verse. Some people call them seven-day candles, for the length of time they keep sending up prayers once lighted. Holly offered Janice and Gene a match.

Janice started to say something, then stopped short and reached down for the candles. Gene lit both wicks easily in the quiet air as Janice studied the prayer on the one she was holding. The gold letters at the top said "Guardian Angel." Her voice quavered and caught, but she gave the words a full reading.

"Spirit protector, who gives me constant protection . . . give comfort to my soul . . . and give strength and courage to my afflicted spirit . . . Restore my faith . . . Amen."

She paused, looking out across the trees to the sawtooth silhouette of Pusch Ridge. We all knew Finger Rock was on the other side, just out of sight. Her voice had become steady. "You think you're not going to make it through...you don't even want to make it through." Gene's arm slid around her shoulders. Her hiking boots stayed planted where they were. "But then you realize you've lived a day, and then another day, and another one, and life isn't anything like you thought it was going to be, or wanted it to be, but it *is* life, and you just go on because you still have it."

She reached into her pocket. Our eyes wouldn't go anywhere else. The Ziploc plastic bag that she drew out bulged with salt-and-pepper colored ash that sparkled in the bright light. It seemed heavy, sagging across her palm. She looked down at it and said quietly, "Then the time comes to give him back, and you just thank God you got the time with him that you did."

I heard her take a long, deep breath. Then she looked at me and said, "So how are we going to do this?"

I cleared my throat, stealing an extra second to round up my far-flung thoughts. I looked at the plastic bag, remembering Keith's paper sack. Holly was ready for this moment.

"I didn't know what you might have, so I made this last night." Holly had converted a tea tin into an airworthy urn, just in case, while I was working late on the plane. I could see blades of grass and flower petals in the delicate handmade paper as she pulled it out of her bag and handed it to Janice.

"Oh, Holly—bless your heart. It's perfect." Janice turned to her husband and said, "Here, you hold it for me."

I watched Janice split open the yellow and blue stripes of the plastic bag and gently finger the ashes into the mouth of the can. Little gray puffs rose as they slumped into their new container. She stuffed the empty bag back in her pocket and took the can from Gene. It sounded full when she clopped the lid snugly into place.

"That will be much easier to manage in the air," I said, mustering a practical tone. "Let's go over to the plane, and I'll show you what to do." We kneeled down together in front of the nose and I pointed out the propeller to them, explaining the need to tip the can at arm's length. Then Janice sat down in the passenger seat and practiced the motion. It looked perfectly ordinary.

As we taxied down the yellow line to the runway, I pulled my microphone tight against my lips and asked Janice to do the same. "Like you're kissing it," I said, "so your lips keep the intercom from picking up the noise of the wind and the engine." Now that we were fused to this little flying skeleton, I needed to tell her a few things.

"I'm going to be looking over your way a lot during the flight, but don't get self-conscious—I'm just checking the engine gauges. They're right behind our shoulders here so they don't get in my way up front." I wiggled my toes on the rudder pedals, which formed the plane's nose. "The pedals on your side move the same as mine. It's okay if you rest your feet against them. Just be sure to let them move."

She could see them going in and out as I steered us along the centerline.

"The air's pretty calm this morning, but there's a shallow zone of turbulence a thousand feet or so above the ground. It'll only last about thirty seconds while we go through it, and I don't think you'll mind it too much. It's completely harmless—just where two different layers of air are rubbing against each other. With our low speed, it won't be bumps so much as wallows, like a rowboat riding the waves. The main thing is, this isn't an endurance contest. If you feel you've had enough at any time, don't hesitate to tell me right away, and we'll turn around and go home."

Janice nodded as I looked over to be sure she heard me. She had both hands wrapped tightly around the canister of ashes in her lap.

When I take passengers up in my plane for the first time, I try to remember how it will seem to them. How the familiar drops away before they know what's happening, how the world as they know it is deconstructing all around them, how empty space presses in like a New York subway crowd. Every little motion of the plane feels like the beginning of a dangerous aerobatic maneuver, and they use their bodies to work a desperate voodoo of safety on us by sheer tetany. They don't know what's normal in this strange new world, but I do. My voice is the intermediary.

"Everything's looking good to me here." We were five hundred feet above the ground. The most dangerous part of the flight was already over. "How're ya doing over there?"

I felt Janice relax a notch just from hearing me talk. "I'm great," she said.

"Good. Now that we're up, I'm going to reduce the power for our climb. You'll hear the engine slow down a little." Even a first-timer knows the motor's pitch is an important sound.

"I'm going to make a gentle turn to the left now to head for the mountain." No surprises. Pusch Ridge swung around to fill the horizon in front of us. I mentioned our speed and altitude just to bring a little order to her senses, then let my left leg drop down off the heel pan to dangle under my seat. I loosened my shoulder harness and leaned forward a bit in my seat. She could see I was feeling at home here, so she began looking around, too.

"I never knew there were so many golf courses!" she said. "You pass them when you're driving around, but up here you can see them all at once. They're everywhere."

"I know. They kinda look out of place, don't they?" The greens lay like bright blobs of molten plastic dribbled through the pale desert vegetation.

I felt the first burble of restless air. "We're going into the turbulence now. I've already been through it this morning, and it's not bad at all. If you can, just relax and ride with it. I know it feels a little unsettling, but there's nothing to worry about."

"Oooh, yeah, there it is. Okay, I'll try." She was brave. When you're perched on the edge of infinity, it's no fun to feel your seat begin to heave and sway. If I could have given her a transfusion of reassurance, I would have. As it was, I concentrated on my own sense of being part of a living sky, feeling its energy through the plane. The motions weren't rhythmic, but they weren't quite random either. By the time I sensed her easing into them, they started to subside. Soon the airframe felt steady again.

She was scrutinizing the ramparts of the mountain ahead. We were rising steadily, but it still loomed large. I said, "That first one there is Pusch Peak. It's about a mile above sea level."

I could see her eyes were sweeping down its flanks, and she said, "Look how the sun's lighting up all those slopes—they're like golden hair. And all the delicate colors in the shadows there. I can see why you like to take pictures up here! The mountain just keeps changing shape. I didn't know it was so complicated. From the road you get an idea of it, but when you get up here you realize you don't really know it at all. It's huge!"

"Yep." I didn't know what else to say. She was a natural.

As we rounded the point of the mountain, our flight path put the rocks on my side of the plane. Janice had the city on her side. She was tracing the streets, trying to get her bearings. It was a worthy task for the moment, full of its own little joys of discovery. But while she was occupied, I lapsed into my own reverie. I could see two things at once. One was a city with a mountain in its way. The other was a mountain besieged by a

city. The visions flipped around inside my head like sparring snakes.

The Santa Catalina Mountains keep Tucson from spreading northward. Pusch Ridge stretches out to the west from the mountain core like an immense bulwark, holding back the creeping tide of buildings. But white-roofed houses push close against the ancient rocks, seeming to jostle each other for the best positions. These are some of Tucson's prime abodes, and the bent of their inhabitants reads clearly from above. I can tell they like water, from all the pools and fountains; quiet, by their distance from neighbors and thoroughfares; privacy, by the walls and hedges and set-backs from the frontage. No one is far from a golf green. The streets cut wide and graceful meanders through the secluded neighborhoods, sometimes passing through a gatehouse before making closed loops among tastefully sequestered villas. And places for new homes are still being carved out of the mountain's shoulder.

Where they first break out of the desert, the rocks are faintly pink. But they keep rising, and eventually they darken with evergreen shrubs and trees. Up that high, the mountain gets too wet to be a desert, so it becomes an island of other life. The savants love to haggle over the boundaries of where this occurs, but even if you can't name the various transitions from desert to mountaintop, it's a fascinating spectacle to behold—especially if you can see it all at once.

From the corner of Skyline Drive and Campbell Avenue, it's obvious that Finger Rock stands at the lower edge of the greening. The crags are bare, but deep green pinyon and juniper trees grow nearby where there's enough soil to sustain them, giving the surrounding slopes a shadowed look.

What's not so obvious is Finger Rock's true form. From the city, it appears to be a graceful pillar barely able to support its own weight. Up close, it becomes something else entirely.

"Oh my God, it's a wall, isn't it?" Janice was craning to keep her eyes on the rock as we drew near. It was her first glimpse.

"Yeah, to me it looks like it used to be part of that knob," I said, pointing to the wooded knoll that rose immediately west of

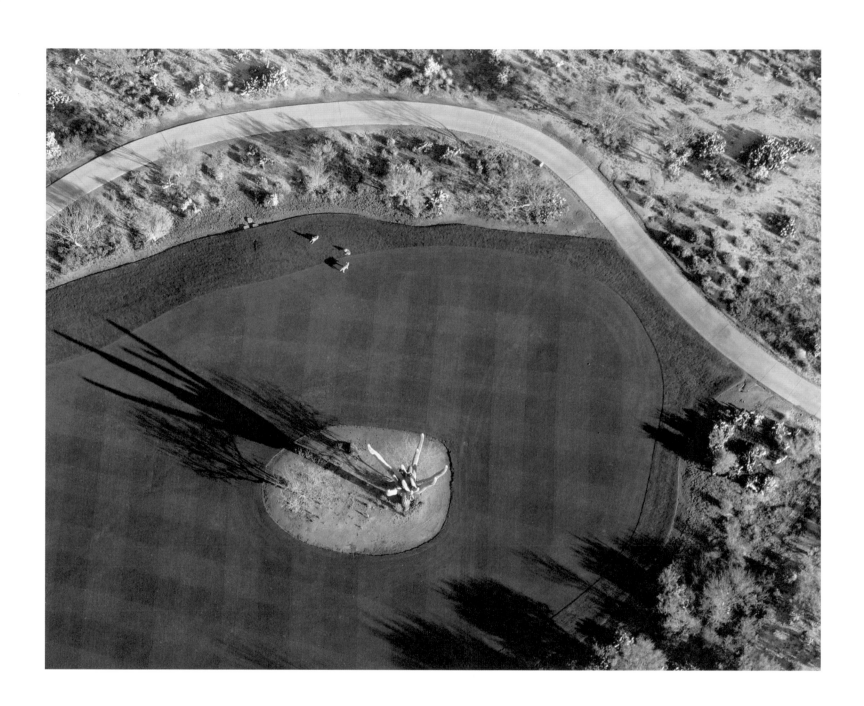

the rock. "As if it was a slab left standing after a demolition." We could see clear joint patterns in the nearby cliffs that made the unexpected shape of the pinnacle seem almost comprehensible.

"You'd never think it looked like this." Janice's voice was full of amazement. As I circled to gain a little more altitude, we drifted over Pima Canyon. Table Mountain stood across the chasm, its acre-sized summit looking like picnic heaven. "I just can't believe how big it all is . . ." I got the feeling she wasn't really talking to me anymore.

Actually, I was glad to know I wasn't the only one who felt this way. Every time I go up in the sky, I remember how little I understand when I'm earthbound. It makes me uneasy about the usual smallness of my mind.

"We're a few hundred feet higher than the rock now. What I'd like to do is pull the power back a bit as we circle around toward the rock, so we're going slower and it's quieter. Then, whenever you're ready . . ."

I didn't know how to be more ceremonious. I was pretty consumed with managing all the details. We were coming in on a long slow approach toward the rock. It wasn't far away at all, and its sense of presence was almost overwhelming. I wondered if she would be able to do it.

I turned my head to glance at the exhaust gas temperature gauge, and I saw she already had her arm out, the way she had practiced before we took off. The rock moved past us as if in slow motion, and I caught sight of a thin white stream trailing out from the urn. It was practically invisible.

She tipped up the can so she could see into it, then put it back out and shook it gently a few times. We were coming closer to the cliff wall just beyond the rock, and I had to look off to the left to plan our route. I banked slowly away from the stone out into the empty space toward the city. The throttle was still back, and I realized I was hearing soft sniffles over the intercom. I decided to bring us around once more, in wordless farewell.

It was downhill all the way back to the airport. Once we cleared the north side of the ridge, I took several deep breaths and cleared some tension out of my body. The mountain had me flushed with adrenaline, which I didn't need any more. It felt good to be over the desert again.

It all began to sink in, what we had done. I had only known about putting bodies in the ground. I watched them go in, and it always seemed too soon. But at least I could return to the exact spot. What would it be like to look at a mountain and know that your loved one was on it . . . everywhere?

It's comforting to think of the body rejoining the elements, but what becomes of its vital spark? I had mine in me, and Janice had hers in her, but both of us were up here because of other vital sparks that no longer had bodies. If they were causing new events in the real world, weren't they still vital? A mystery was bubbling up inside me, and I didn't hold it down. I could feel my brothers, my friends, my dogs. They weren't any "where." They were in me. I was holding them, and they were holding me. I closed my eyes for a moment and let the plane fly itself while the wind swept away my tears.

Gene was standing by himself when we taxied in. He told us Holly had been called to a birth before we'd even got off the ground. I felt disappointed that she was gone, but grateful for her help getting this mission underway. No matter what, the flow of life is unending.

While I refueled the plane and checked it over, Janice prepped Gene for his ride. She encouraged him to wear the windproof pants I offered. "It's colder than you think," she said. He showed me the little clay flute he had filled with ashes, asking if we'd be able to get close enough to drop it on Finger Rock. Probably not, I told him, since it's almost impossible to make an accurate airdrop without a lot of practice. Janice had briefed him on her experience, so I let him consider his options as we took off and climbed toward the mountain. We arrived over Finger Rock twelve minutes later.

Gene seemed more at ease with the movements of the plane than Janice did, which was a good thing, because the sun-warmed rocks were beginning to stir the air. I made a wide cir-

cle above the pinnacle, honing my altitude and flight path for the first approach.

"Okay, Gene, we'll be set up pretty good this next time around. If you want to just look it over to start with, that'll be fine. We can make several passes."

He pulled the microphone close like a pro. "All set." I could see he had the flute out of his pocket, waiting in his right hand.

The engine pitch shifted ever so faintly. I looked down—no, the throttle hadn't been bumped. I scanned the gauges. Everything normal. Was I imagining it? I certainly knew I didn't *want* to hear anything unusual . . . I decided to pull the throttle back a little just as a precaution.

Gene sensed my change of focus. "What's happening?" he asked.

"I'm just checking over the engine," I said.

And then it stopped. One second on, next second off. Not a whimper or a cough.

"Okay, we just had the engine quit." I immediately slipped into my professional pilot mode of talking myself through an emergency. There's real value in hearing a calm voice at such moments, even if it's your own.

"Why did it quit?" Gene asked innocently.

"I don't know, but it did." I was still recovering from my disbelief.

"What are we going to do?"

"Well, right now we're gliding just fine, and I'm looking for a place to land."

I actually had one already picked out. I'd had my eyes on it when Janice and I were here earlier.

We were very high, so I had plenty of time to look the plane over. I turned around in my seat. The propeller, the fuel tanks and feed line, the bottom of the engine—no signs of trouble. I checked the throttle, ignition switches, and choke lever—there was nothing more I could do. We were going down to stay.

"I'm looking at three places." I would've said this even if I was alone, but Gene thought I was talking to him. Just as

well—crew and passenger briefing all in one. "The first is the construction area right below us. It's a good choice because it's close, and no one is around. The second would be a street."

I paused as I scanned for the sort of space that would make me feel comfortable. There were several, but as I watched them, I could see enough vehicles moving around to cool my enthusiasm for that option. Drivers aren't in the habit of watching for air traffic.

"The third would be a golf course. I see La Paloma Resort—we could make it over there without any trouble." The thought of landing on grass was appealing, but again, I remembered it was Saturday morning. People would be out. My approach would be silent, so I'd have to rely on being seen. Not good.

"Okay, so I'm setting up an approach to the construction site. I have to decide which way to land. Surface wind doesn't look like a factor, so I'll choose on the basis of the obstacles."

I still had a couple of thousand feet to descend, and we were right over the landing zone. As I dangled my feet in the whistling breeze, I studied every detail below me. It was a wide dirt road that appeared to be gated off on the west end, where it joined a paved street. Earth-movers were parked well off to the side on one of the empty lots. There didn't seem to be anyone around at all. A tall saguaro cactus stood close by the road near the west end, with a stone wall right across from it. I'd have to miss those. The one thing I couldn't see was slope. It wouldn't be good to land downhill, but how to tell before it was too late?

I noticed that the east end of the road looked unfinished. It seemed to go down into a ravine and stop. Just beyond it stood a three-story house high up on the opposite side of the ravine. I could see that this whole area was right against the mountain, so my guess was that the ravine was steep—and not a good touchdown zone.

"All right. We'll be landing from the west, with left turns on the approach. I see both the saguaro and the stone wall. I'll stay above them, and land long."

Now that I had worked out a plan, I began to think about Gene again. "This is going to be okay, you know. We have a good place to land, and everything's looking fine."

"Oh, this is pretty cool. I'm doing great." He sounded sincere, so I took him at his word.

I faced two dangers now. One was more psychological. As you get closer to a forced landing site, it starts to look more real, perhaps less like you hoped it would. There can be a strong temptation to change your mind at the last minute, and it's one situation where the greener grass syndrome will probably kill you. I resolved to stick with my plan, come what might.

The other danger was misjudging the glidepath and ending up too low or too high to make the landing spot. I felt confident about this because I knew my plane well, and I had plenty of time to set up the approach. But with Gene on board, the plane would be much less forgiving, especially if we got too low or slow. I absolutely had to get it right the first time.

As I made one last pass over the site, my attention narrowed. Gene might have been talking to me, but I wasn't listening. All I could see was the space remaining between us and the touchdown area. I sensed the plane's motion as if it was my own body, and it quickly became the most important thing in the universe.

To hit the saguaro would have been fatal, of course, but being more than a few feet above it would have been wasting runway, something I could ill afford. We nearly swiped it as we passed over, which was perfect. Our touchdown was gentle, an anticlimax, and the road was plenty smooth, but with the extra speed I'd been carrying, I was still keenly interested in what lay over the crest of the hill ahead. I had about two seconds to take my pick once I saw the situation. One choice was straight ahead, down a long steep descent into the dead-end ravine. The other choice was toward a crude earthen ramp rising massively into the air to the left of the road. Neither looked good, but only the ramp held any hope of stopping us safely, so I aimed for it. This was one time, after nine years of not needing them, when it would have been nice to have brakes.

The bulldozer hadn't made the ramp for runaway airplanes. It was simply a place to put extra fill, so the surface was scarred with deep ruts where the Caterpillar tracks had gouged into the soft earth. We hit one at right angles just where the slope changed from down to up, and the front of the plane stuffed into the earth in a sudden spray of dirt. The tail vaulted high into the air behind us, and for a moment the plane teetered on its nose, as if we were standing on the rudder pedals. Then it fell back on its wheels, motionless. The air was eerily quiet.

"Well, here we are," I said as I released the catch on my harness and stood up. "Are you okay?" I could hardly feel the ground underneath me, I was so charged with adrenaline.

"Yeah, yeah, sure. I'm fine." Gene started fishing for his seatbelt. We both felt a little stunned. It was over so fast.

"Let's pull the plane back up the hill and park it beside that heavy equipment where it'll be out of sight. Then we'll find a phone." We were both grateful to have work to do, but the flight suits and long underwear had to go. One day soon, it would be indecent to take off our clothes in the middle of this new road, but today, incredibly, the place was deserted.

Gene and I were out by the paved street now, talking to three young men who walked over from a nearby building project. One of them had offered us his cell phone and was telling us how to get here so we could give Janice directions. Suddenly we heard footsteps behind us.

"Who's the pilot? Is one of you guys the pilot?" A sweaty man was running in place, as if he couldn't be bothered to stop exercising while he interrupted us. His bright yellow visor shaded his ruddy face, and his sunglass lenses looked solid black. I couldn't tell much about him other than that he had curly blond hair and a lean build. And he really wanted to know who the pilot was.

"I am," I said neutrally. I felt like I was being set up, but I wasn't in a position to get too testy. Maybe this guy owned the property.

He stopped jogging and thrust his hand out toward my stomach. It took me a second to realize it was open and friendly.

"I just want to shake your hand, buddy. That was one hell of a piece of flying you did there. I watched the whole thing. I was up the Finger Rock trail a ways when I heard your engine go off." He was pointing up the mountain beside us. "And it took me a while to find you in the sky, but then I watched you come all the way down and land. It was incredible. You must be a really good pilot."

"Well…thanks," I stammered. "We were lucky to have this road here."

"I saw you skim over that saguaro and set 'er down on the dirt. That wasn't luck, man."

I realized I shouldn't quibble over details and just take the compliment. "Yeah, well, I'm glad it turned out okay. Thanks a lot." And he was gone. Others had gathered around in the commotion, and people were looking at me quizzically. It must have sounded very strange. There wasn't a plane in sight.

"Janice, this is Adriel."

Lucky for us, she had her cell phone, but I could sense her struggling to comprehend what I was saying.

"Everything is okay. We had an unscheduled landing at the bottom of Finger Rock and we're both fine, but we need you to come pick us up. If you have something to write on, I'll give you the directions."

I paused while her questions poured out.

"Well, the engine quit, so we had to land. We came down on a dirt road just across the street from the parking lot for the Finger Rock trailhead, all the way against the mountain at the north end of Alvernon Way. Just come in your van, and I'll bring the trailer over later to get the plane. We have it parked for safe keeping until I come back."

We had a lot to talk about on the ride back to the airport. Gene told her about the ashes. We realized we had both been thinking the same thing right after the engine quit . . . maybe there was still time to go ahead and scatter them. Curiously, each of us had decided against it without mentioning it to the other.

Janice was the first to bring up the next issue. "Oh, Gene, that could've been me up there instead of you." The relief in her voice made me breathe a prayer of thanks that it had worked out this way. Each of us was glad she was spared the ordeal. But I had to address Gene.

"You know, I'm sorry you had to go through this, Gene. It's very unusual, and for it to happen on this, of all flights…You're a great sport."

He turned around in the front seat to face me. "Well I'm sorry about your plane, and it would've been nice to get all the ashes out, but at least Janice got a good chance to do it. And I thought the ride was great. I always wondered what would happen if an airplane lost power, and now I know. It's one more thing to cross off my list!"

Janice looked at him sharply. "What list is that?" She sounded leery.

"You know, things you want to experience in your life."

She hesitated, then drew her eyes away from the road for an instant to deliver her next question. "What else do you have on that list that I don't know about, Gene?"

"Hmmm." His face was deadpan, but I caught him flashing Janice a wink. "Maybe some things are best kept to oneself."

I almost had to arm wrestle Gene to turn down his offer to help me retrieve the plane, but I knew what I was doing. It truly was a one-person job, and I needed some time alone. We parted with hugs back at the airport, and I packed up for the recovery operation. When I arrived on the scene with my trailer, I was relieved to find the site still deserted. The entrance gate was padlocked shut, so I dismantled one set of hinges and improvised an opening large enough to drive through. Fortunately the plane was over the rise and out of view of the road, so once I was inside with the fence closed behind me, I could work undisturbed.

I parked the trailer near the plane, and stepped out, glad for my first chance to be alone with the aftermath. I took an inven-

tory of the damage. Both landing gear legs were bent. The very front end of the frame would need some welding and straightening. And the tail wheel assembly was twisted. This was the worst, because it tied into some complicated structure that I'd have to rebuild. But nothing else was wrong—except the engine.

All day long it had haunted me. What went wrong? Now I could investigate. I went over it system by system. Nothing.

I tried to start it, spinning the propeller by hand, the way I always do. It wouldn't start, but I could tell a lot about the engine just by what I was feeling through the blades. It took a few whirls, but I began to notice something very subtle that was new—a slight quiver during rotation. The faster I turned the prop, the more I could feel it. I pictured the motor's innards and what that quiver might mean.

I left the plane and walked among the monstrous trucks and graders to the edge of the lot. The view of Tucson was breathtaking. Every place in front of me seemed lower, even subordinate. This would no doubt soon be someone's private power spot, but for the moment, it was mine. I sat down to think.

Knowable cause. Until I had one in hand, I needed a theory. That's all I had right now, but it was so much more than an hour ago, and it was making good sense. Say a crankshaft bearing disintegrated deep inside the engine. There would be no warning and no way to prevent it, short of an early overhaul. I was realizing what I needed to know: I didn't cause the failure by neglect, ignorance, or ineptitude. I could feel the relief spreading through my body.

I shuddered to think how differently this could have turned out. What if the bearing had given out on one of my recent flights in the Superstition Mountains? Or one of those mornings over the Grand Canyon? It made me dizzy to think of the possibilities. I take calculated risks on every photo mission, and each flight has moments when a sudden engine failure like today's could be much worse trouble than this.

Bands of cirrus clouds were gliding up over the city from Mexico. The evening light shimmered across the fibrous streamers in utterly implausible colors, and I thought of endings, of dying. I thought of how absolute is the tyranny of events when they cause one of us to pass from this world, how those left behind yearn to roll back time and hold that life close for just one more precious instant. I stood up and stretched as far as I could reach, feeling full of my own life spark. And I knew this was that instant.

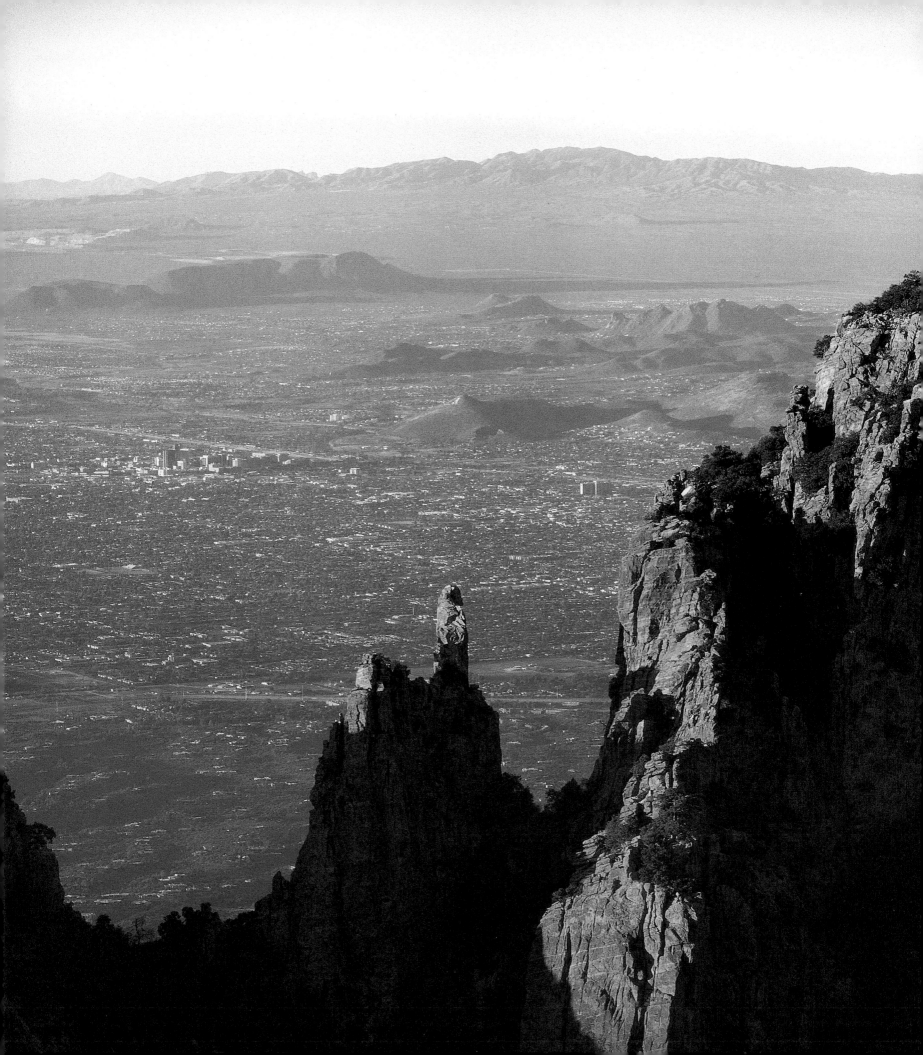

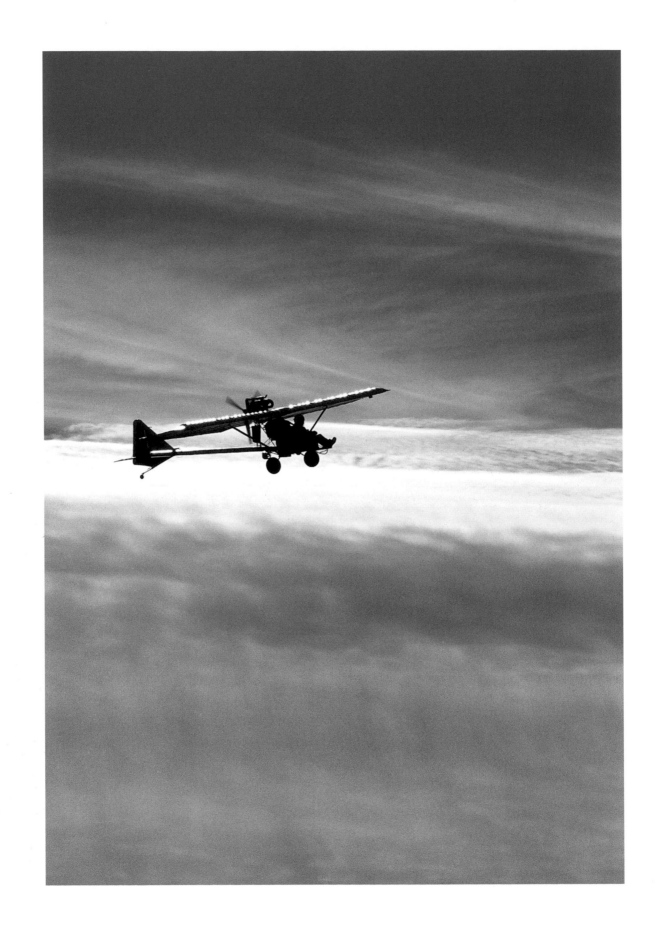

The stories and images of this odyssey bear witness to what every adventurer knows: having the right equipment is one of the exquisite pleasures of unusual work.

I fly a Kolb Twinstar, a two seat airplane (legally not an ultralight), which I adapted during construction for aerial photography. I chose it because it flies slowly (35 to 75 mph) and economically (3.5 gallons of fuel per hour). It is strong and resilient, yet lightweight (450 lbs) and easy to fly. The rear-mounted engine is a water-cooled, two-cycle, 66 horsepower Rotax model 582, and it runs admirably from 0 to 15,000 feet, though most times I fly below 1,000 feet. The lack of a front

enclosure gives me unparalleled freedom while shooting, and the plane's rapid-folding design means I can trailer (rather than fly) it to distant shooting locations. I always fly with a BRS rocket-deployed parachute. This can bring the entire plane down safely in an emergency, and though I haven't yet needed it, knowing it's there brings me great peace of mind when I fly over inhospitable terrain.

I take all my photographs by holding the camera in my hands, putting the viewfinder to my eye, and composing the image just as I would on the ground. Since blurred pictures are the aerial photographer's bane, I use a Kenyon gyrostabilizer (KS-6) to help steady my hand. Piloting and shooting at the

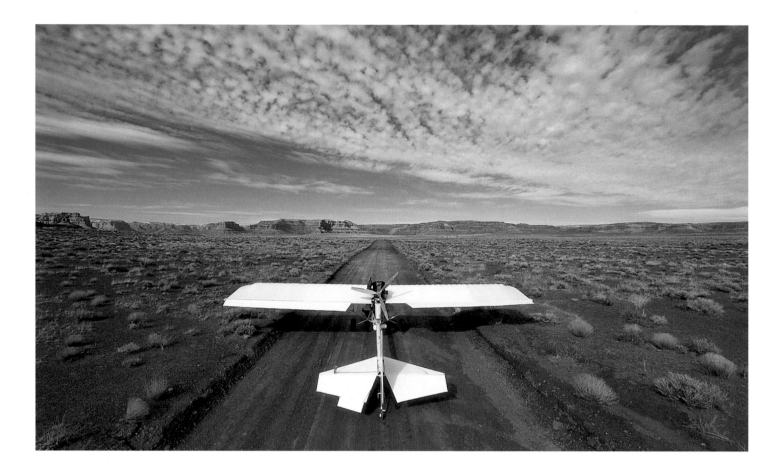

same time are essential to my methodology; I often don't know exactly where I want to be for a picture until I'm there.

I use a strap to connect my right leg and the control stick. Though it took some practice to master, the arrangement affords me satisfactory control of the airplane while freeing both my hands for the camera. I have replaced the passenger seat beside me with a fiberglass pod that I built expressly for carrying my photographic gear. The interior space of the pod is accessible to me in flight, and it's where I keep maps, film, notes and emergency rations.

I use Pentax camera systems, both the 67 and the 645N. The latter is my preferred outfit because of its superior electronic controls. Having labored for years without their benefit, I heartily embrace autofocus, autoexposure, autobracketing and motor drive technology. In an environment where opportunities are brief and unique, systems that work quickly, accurately, and dependably are priceless. They foster, rather than usurp, creativity.

I carry ten different lenses, and I use all of them on almost every flight. I shoot eight rolls of film on a typical sortie, and since I change both lenses and film on my lap in the open wind, I've learned the value of mindfulness.

My staple films are Fujichrome MS 100/1000, Provia 100, and Kodak Ektachrome E100VS. They each respond well to push-processing, which is a technique of underexposing the film in the camera (because of low light/fast shutter speed), and then overdeveloping it in the lab to compensate. MS is the star performer in this area; its ability to capture dim light on the fly wrested a number of photographs in this book from the jaws of impossibility.

Good apparatus liberates the imagination—but it may also capture it. Technology is beguiling, and it can refract the spiritual rhumb line of the hardiest voyager. Aerial photography is especially alluring because of all of its requisite gadgets and skills, so I must remind myself often: vision comes from the heart; tools merely give it form.